ALPHONSE

Mucha

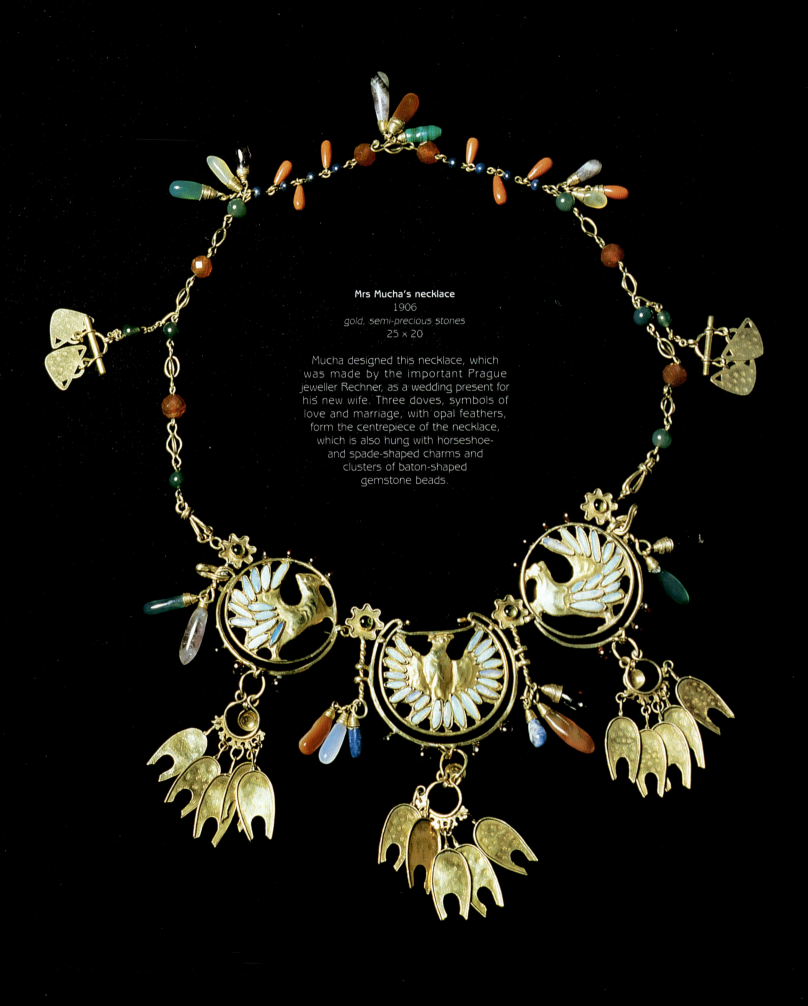

Mrs Mucha's necklace
1906
gold, semi-precious stones
25 × 20

Mucha designed this necklace, which
was made by the important Prague
jeweller Rechner, as a wedding present for
his new wife. Three doves, symbols of
love and marriage, with opal feathers,
form the centrepiece of the necklace,
which is also hung with horseshoe-
and spade-shaped charms and
clusters of baton-shaped
gemstone beads.

ALPHONSE
Mucha

Celebrating the creation of
the Mucha Museum, Prague

By Sarah Mucha
with an introduction by Ronald F. Lipp
and contributions by Victor Arwas,
Anna Dvořák, Jan Mlčoch and Petr Wittlich

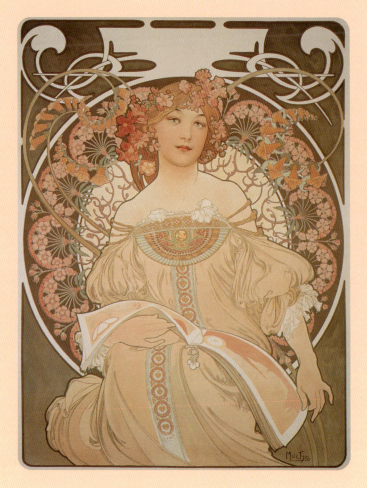

Mucha Limited

in association with
Malcolm Saunders Publishing Ltd

This book is dedicated to the memory of
The Lord Menuhin OM KBE, Honorary Patron of
the Mucha Foundation, a valued friend and supporter.

The publishers would like to extend
a special thank you to:
Sebastian Pawlowski for his commitment to and
support of the Mucha Museum in Prague;
Professor Petr Wittlich for his contribution to
the re-evaluation of the work of Mucha;
Dr Katharina Sayn Wittgenstein, the first director of the
Mucha Museum, for her enthusiasm and dedication and
her continuing support of the Mucha Foundation;
Hana Laštovicková and all the staff of the Mucha Museum;
all the authors for their invaluable contributions to this book;
Jean Marie Bruson of Musée Carnavalet and Dušan Seidl of
Obecní dům; Jilly Arbuthnott, Simon Frazer, Jitka Martinová,
Marcus Mucha and C. J. Spiers for their editorial support;
above all Malcolm Saunders without whom we would
not have been able to start, let alone to finish.

This edition first published 2000 by Mucha Ltd.
in association with Malcolm Saunders Publishing Ltd.

ISBN 0 9536322 0 2

Editor: Sarah Mucha
Designer: Roger Kohn
Translations from Czech: Karolína Vočadlová, Vladimíra Žáková

Made and printed in the Czech Republic by Graspo CZ, a. s.

Measurements are given height first in centimetres

CONTENTS

PREFACE
by The Mucha Foundation

THE MUCHA FOUNDATION was established in 1992 by Geraldine and John Mucha, the daughter-in-law and grandson of Alphonse Mucha, following the death of the artist's son, Jiří. Mucha is, without question, one of the greatest and most internationally recognised Czech artists. It is the mission of the Mucha Foundation to give Mucha's work the best possible chance of being preserved for future generations and also to promote his work as widely as possible, in keeping with Mucha's own belief in the universality of art and its central position in the life of mankind.

Within the context of our quest to make Mucha's work more accessible, it had always been our dream that there would one day be a permanent exhibition of his work in Prague. The creation of the Mucha Museum, which was formally opened in February 1998 by Mrs Dagmar Havlová, wife of President Václav Havel, has more than fulfilled that dream. For the first time in the history of the Czech nation, a museum specifically dedicated to Mucha has been established. This great achievement would not have been possible without the support of Mr Sebastian Pawlowski and his company COPA and we are deeply grateful for their enthusiasm for the project. They have not only created a marvellous space for the Museum but have also carried out a magnificent and sensitive restoration of the Kaunický Palace.

Naturally there have been many people who have worked ceaselessly in enabling us to convert our dream into reality. In particular we would like to mention Professor Petr Wittlich, with whom we have worked many times, who curated the exhibition and Dr Katharina Sayn Wittgenstein, the Museum's first director. With the passage of time it is becoming clear that the Museum is fulfilling its aims and satisfying the thirst of the Czech people, Mucha enthusiasts and visitors to Prague, giving them within a limited space a snapshot of both Mucha the artist and also Mucha the man. In this the Museum is being supported by a team of wonderfully dedicated and professional staff who ensure that each visit, whether for the first or fifth time, is pure joy.

Mucha's posters and decorative panels are considered to be landmarks in the history of modern graphic art and he is best known as the supreme exponent of Art Nouveau. But his artistic concerns embraced so much more than 'mere decoration'. With the creation of the Museum we were concerned that visitors should be given the opportunity to see a selection of not only the posters and decorative panels but also some of his less well known pastels, drawings, oils and photographs, records of the visionary, and sometimes dark, depths of Mucha's imagination, works which serve to illuminate a dimension of his creative personality which has so far not been fully appreciated and which reveal the profound concepts behind his decorative work. It was also our hope that as we revealed a more rounded picture of the work, a more rounded picture of the man would also appear.

It is our intention in this book both to celebrate the arrival of the Mucha Museum and also to build upon its vision, to reflect the exhibition and to develop its themes. There are therefore pictures in the book which are not in the exhibition as we take advantage of the opportunity offered by the Museum to promote a broader knowledge of Mucha and his work. The Museum is, after all, simply an introduction to Mucha and we hope that visitors will be inspired to seek him out in other places – in Moravia at Moravský Krumlov and Ivančice, in Prague at St Vitus Cathedral and Obecní dům, in Paris at the Musée Carnavalet, the Musée d'Orsay and the Musée des Arts Décoratifs.

Today, however, what is most important is that you, whether you are already a Mucha enthusiast and familiar with Mucha's work or not, find this selection of his work not only interesting but also surprising and challenging. It was Mucha's deeply-held belief that art should be made readily available to the general public and be seen and enjoyed by as many people as possible. We hope that this celebratory book continues this tradition and communicates afresh the interests, passions and concerns of Mucha's artistic vision.

Geraldine Mucha
John Mucha

Mucha in his studio
Rue du Val-de-Grâce, Paris
c 1898

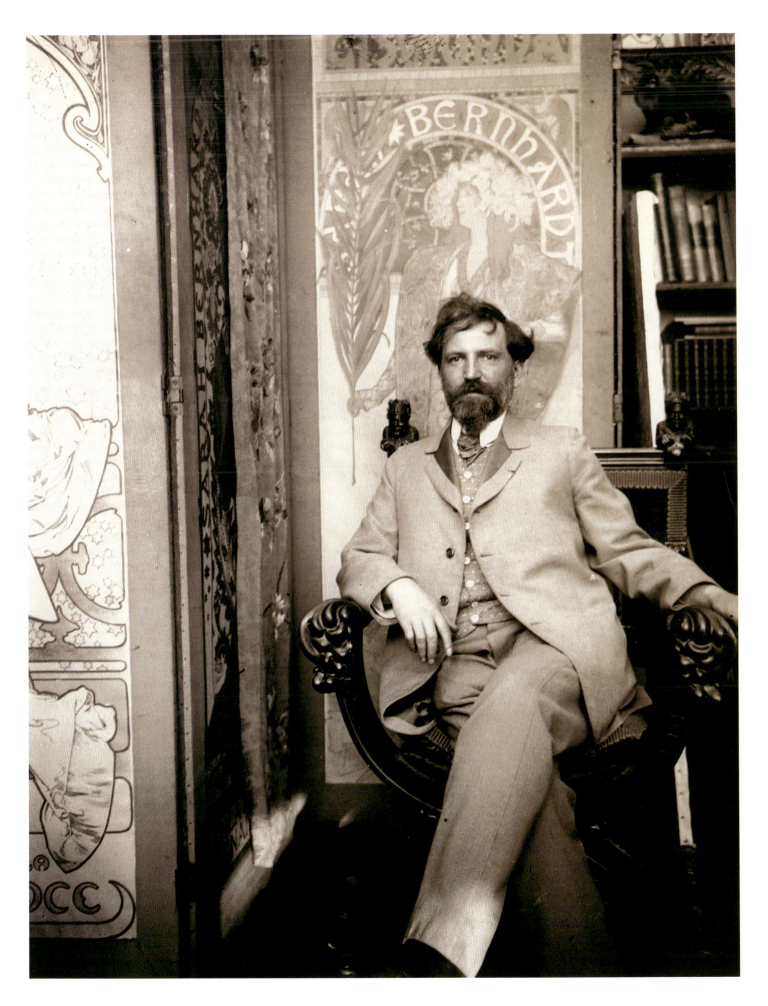

A COMPLETE VISION

by Petr Wittlich

Professor of Art History, Charles University, Prague

As the 19th century drew to its close, the belief that mankind was on the verge of breaking open a path which would lead to the fulfilment of its highest destiny, a destiny commensurate with its elevated natural position, was widely held by philosophers and artists alike. The name of Alphonse Mucha is inseparably linked to this belief. This noble and idealistic theory was in part a positive response to the unprecedented advances in both technology and economics at that time. It was also, however, an expression of an intention to move beyond the facile materialistic slogans which greeted this progress and to focus on the real human and social dimensions involved. Art was to become the tool to educate the masses, using for this lofty purpose every gift of sensuality at its command.

At that time the obvious model for a complete work of art, a work which combined in itself all different art forms to make the most powerful impression possible on the audience, was theatre. Mucha first came into contact with theatre at the age of 22 in Vienna, where he worked as a painter of theatre scenery. In Mucha's case, however, the sensuality of the theatrical illusion was tempered by his childhood experiences of the Catholic masses in which he participated for many years as a member of the choir at St Peter's Church in Brno in Moravia. His subsequent studies at the Academy of Art in Munich led him by way of the contemporary cult of historical painting to his own particular vision of history as a series of dramatic and fateful scenes.

In 1887 the young Mucha set out for Paris, the centre of international artistic activity, and there it was that all his great desires and expectations were finally fulfilled. At first, of course, he had to endure years of self denial, of that 'cheerful poverty' which is the lot of the young artist, when he eked out a living as a poorly paid illustrator. The fact that he did not abandon his chosen career was only thanks to his boundless vitality and idealistic fanaticism. On the other hand, as a member of the bohemian circle which centred on Madame Charlotte's crémerie in the rue de la Grande Chaumière, he met remarkable personalities who profoundly influenced the history of modern culture such as Paul Gauguin and August Strindberg, and these acquaintances influenced the spiritual perceptions of the young Central European in an unusual way. Through them, Mucha learned about the ideas of Symbolism and the synthesis of art, ideas which became significant influences on the development of his own art.

The legendary turning point of Mucha's destiny came as 1894 made way for 1895 when he designed his first poster for the much admired star of Parisian theatre, Sarah Bernhardt. This public success opened the floodgates of Mucha's imagination and enabled him to become a preeminent exponent of the new European decorative style – Art Nouveau. From today's historical perspective, Art Nouveau is perceived as a coherent artistic

style, as one of the last great attempts to give European art a common basis and formal character. It is actually much more interesting to see how in the final twenty years of the 19th century this movement was created by the flowing together of a very diverse collection of personalities from many very different localities. Within the context of this movement, Alphonse Mucha developed his own *style Mucha* which had its own unique attributes, although it clearly fits within the general framework of the outlook of the fin-de-siècle. The voluptuous female figure, which in Mucha's posters and decorative panneaux is often encircled by the crescent moon of an ornamental halo, is the symbolic personification of the 'World Soul', oscillating between the world of ideal values and the sensual reality of our life. In his beautiful book devoted to the theme of the Lord's Prayer 1898, a project in which Mucha's neo-idealism is explicitly stated, mankind's situation is expressed as a dramatic fight between light and darkness, reconciled by the message of cosmic love. This noble message is implicit in all Mucha's public pictures, no matter how commercial in character they appear.

What is most remarkable is how total Mucha's vision is, how it touches upon all aspects of life and ennobles them through art. When, after the turn of the century, Mucha summarised his broad experience of Art Nouveau in his two publications for designers, *Documents décoratifs* and *Figures décoratives*, he not only revealed the intimate world of the fin-de-siècle woman and her ornamentation, but also made available a sumptuous repertoire of creative ideas for all arts and crafts as well as decorative architecture. Mucha's ornamentation has as its basis the concept of the single natural life force, which is expressed through the decorative curve.

For Mucha ornamentation is born from a need for self expression – witness his drawings and pastels which reveal the drama behind his vision. It is these works which confirm that Mucha was never concerned with 'mere decoration' and that he never compromised his professionalism. These works shed light on the innermost identity of Mucha's art, proving that even in his late period, after he had returned to Bohemia for good, he did not radically change his world view.

Central to Mucha's Czech posters, which he created into the 1920s, as to all his later works, including the monumental canvases of the *Slav Epic*, is the concept of the symbolic ideal of the vital moral force of the 'World Soul' which Mucha believed should provide the spiritual guidance for the revived Czech nation. Mucha's patriotism and his sense of the folk roots of a national life were in no sense a contradiction to his worldliness. From the time of his youthful enthusiasm, throughout the period of his fame in Paris and ultimately to his realisation of how an understanding of history can shape the destiny of a nation, Alphonse Mucha's lasting concern remains the necessity of combining beauty and goodness.

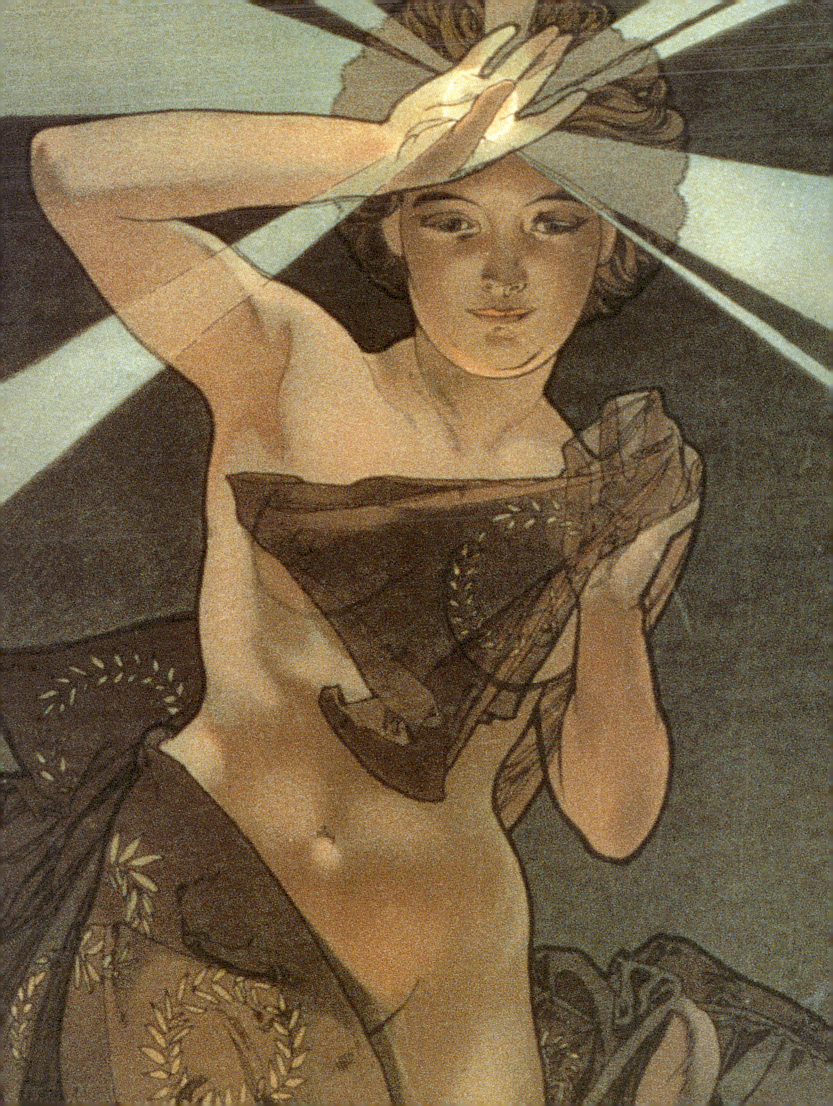

ALPHONSE MUCHA
THE MESSAGE AND THE MAN[1]

by Ronald F. Lipp

The Rediscovery of Mucha

THE ESTABLISHMENT of the Mucha Museum nearly sixty years after the artist's death creates for the first time in his homeland a permanent venue exclusively dedicated to the work of Alphonse Mucha, surely one of the greatest, most celebrated and yet largely misunderstood Czech artists. The Museum is part of a worldwide revival and reappraisal of his art and life that has, within the last ten years, included exhibitions throughout Japan in 1989, in London in 1993, at Prague Castle and in Paris and Krems, Austria, in 1994, in Lisbon, Hamburg and Brussels in 1997 and across the United States in 1998 and 1999.

This revival is in fact the second since the artist's death in Prague in 1939. The first occurred in the 1960s as part of a larger rediscovery in the West of Art Nouveau, the Decorative style usually associated with the decades bracketing the turn of the last century in Paris, Brussels and other European art centres. Happily the renewed appetite for this genre coincided with the efforts of Mucha's son, Jiří, and others to reacquaint the world with Mucha, whose work and very existence had been largely forgotten during the previous thirty years. Mucha was thereby retrieved from neglect and his reputation as one of the consummate masters of Decorative art restored. However, because the focus of the revival was on that style and on the style's form rather than its underlying substance, the large and important body of Mucha's non-Decorative art remained largely unrecognised and his Decorative creations as much misunderstood as rediscovered. It is therefore both needful

and timely that there should now be a second Mucha revival.

Mucha was born in obscurity in the mid-19th century in a backwater village of the Hapsburg Empire. He remained in obscurity, learning the artist's craft in Vienna, Munich and Paris, until the age of 35 when overnight and without the slightest forewarning he became a sensation in the Art Nouveau world of Paris, then the artistic capital of Europe. In the decade after 1895 *le style Mucha* – expressed in posters, book and magazine illustrations, screens and decorative panels, stained glass windows, book design, jewellery, interior decoration, theatrical sets and costumes, sculpture and architectural conceptions – virtually defined the Parisian version of the New Art. He was widely exhibited, shamelessly copied and the object of extravagant attention from the public and the media. Nor was his appeal limited to Europe. His first American trip in 1904 was heralded by *The New York Daily News*, which proclaimed him as 'the world's greatest decorative artist' and published a special issue with four-colour reproductions of his work.

Yet his fame vanished almost as dramatically as it had erupted. At the height of his popularity he chose to abandon Paris and, after a dalliance in America, to return to the homeland of his youth. He continued to work in Bohemia for another 29 years, creating some of his most important work, including the monumental *Slav Epic* which he regarded as his greatest achievement. Yet the creations of his Czech years have, until recently, been virtually unknown in the

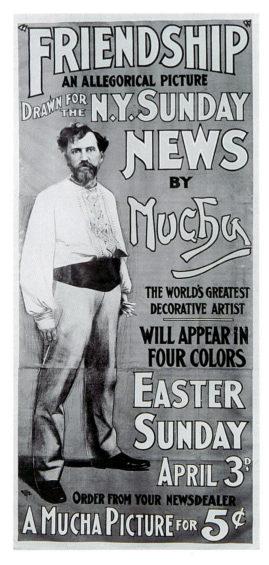

Billboard advertisement for the reproduction of *Friendship* in the *New York Sunday News* 1904

West. Indeed, the neglect of his career has been so complete that important aspects of even his Parisian work are only now coming to light and his papers – diaries, letters and notebooks – remain, for lack of funds, largely untranslated, unarchived and unexamined. The collective amnesia regarding Mucha has been so complete that as recently as 1989 a scholarly book devoted to Art Nouveau in fin-de-siècle France contained not a single reference to him.[2] A year later another text surveying Art Nouveau graphics across Europe included Mucha in a chapter discussing the artists of Austro-Hungary.[3]

The decline and disappearance of Mucha from the world's consciousness proceeded at first from changes in popular taste. Shortly after the turn of the century the avant-garde shifted its attention to the Fauves, Cubists, Expressionists and other variations of modernity. Art Nouveau seemed too familiar, conventional and boring. After the First World War social sensibilities shifted radically as well. The horrors of the war, the disturbing insights of Freud and Einstein, the upheaval caused by the Bolshevik revolution and the threat of its spread to the West and, finally, the trauma of hyperinflation and global depression called for an art that resonated the new existential realities. Mucha's Madonna and perhaps even Gustav Klimt's succubus seemed quaintly naive echoes from an age now lost.

In Mucha's case, indifference was trumped by vocal hostility, official suppression and finally malign neglect. Mucha's return to Prague in 1910 was greeted with invective and suspicion. The immediate occasion for his repatriation was the construction of Obecní dům, the Prague Municipal House, the last great Art Nouveau structure to be erected in Europe. His larger purpose in returning to his homeland was to devote himself to the creation of the Slav Epic, a series of twenty monumental canvases that were to celebrate the struggles and aspirations of the Slav peoples, among them his own Czech nation. It was to be his edifice, the fullest expression of his own mature aesthetic and moral vision. Along the way he also poured himself unsparingly into civic and philanthropic projects for his homeland including after its independence in 1918 the creation of myriad symbols of the new Czechoslovak Republic.

To Mucha's critics among the Czech cultural elites and in the artistic community, he was an outsider bringing foreign values and unwanted advice to a country he no longer understood. His celebration of Czech patriotism and folk traditions was both passé and something of an embarrassment.

In 1939 the Germans invaded Bohemia following the treachery at Munich. Mucha, then 79, was honoured by inclusion in the first waves of Nazi interrogations. He was known as a prominent Freemason, a Judophile and a champion of Czech freedom and for all those reasons an enemy of the new order. Old and ill, he died soon afterwards.

For the duration of the Nazi occupation, his work was interdicted and the Slav Epic canvases were hidden to prevent their seizure and destruction. In 1948, after three years of post-war freedom, the Czech nation embraced Communism and fell into the Soviet orbit. Mucha's works were once again condemned in official Czech circles, now as bourgeois decadence. During the worst years of Stalinism Mucha's son, Jiří, was imprisoned as a spy, the family was expelled from its home and state officials continued to suppress, confiscate and even destroy Mucha's art. As the regime eased Mucha's creations and his devotion to Czech culture were largely forgotten and ignored. In the early 1960s the Slav Epic was permitted to be exhibited but only in the small Moravian village of Moravský Krumlov.

The Velvet Revolution of November 1989 promised the end of half a century of nearly uninterrupted totalitarian rule and foreign domination. A statue of Tomáš Masaryk, the President and guiding spirit of the First Republic, beloved by the Czech people and hated by Communists and Nazis alike, was briefly erected at the foot of Wenceslas Square, a tangible symbol of the return of Czech freedom and autonomy. The new President, Václav Havel, celebrated the humanistic ideals of Masaryk and the First Republic and expressed the widely shared hope that these values might again be instilled in Czech society. The First Republic had been Mucha's Republic, for which he had laboured tirelessly. Its ideals were his as well, which he strove to infuse in all his work and especially the Epic. Yet, oddly, the amnesia over Mucha persisted. Except for a brief exhibition in 1994, no permanent or continuing showing of Mucha's work could be found in the Czech capital prior to the establishment of the Mucha Museum in February 1998. When in the mid-1990s a Prague journalist inquired of a senior government official why no venue existed to display Mucha's art, the terse response was, 'Why Mucha?'

The strange thing was that at that moment the streets of Prague were filled with Mucha. Calendars, posters and other reproductions of Mucha's works were among the most popular art wares in Prague's shops and market stalls. In fact it has always been the case that popular demand has been the foundation and the sustenance of Mucha's appeal. In 1920, long after the heyday of Mucha's Art Nouveau success, a final American exhibition of his work at museums in Chicago and New York was attended by 600,000 visitors. In 1936, near the end of his life, a retrospective exhibition at the Jeu de Paume in Paris was also a great popular success. Similarly, the international revivals of the 1960s and today, while enjoying favourable critical reception, have been notable above all for the public's enthusiasm. And in Moravský Krumlov the exhibition of the Slav Epic remains an object of pilgrimage for many Czech families and school children, despite its remote location and the relative lack of publicity.

With the opening of the Mucha Museum the time has come to look at the artist and his art with fresh eyes; if we do, we shall comprehend the reason for both the continuing hostility and the enduring devotion that he and it provoke. Mucha's work presents the subversively moving and provocative vision of one of the most versatile, imaginative and deeply impassioned artists of the past century. And far from being the outmoded stuff of a forgotten age, it is vitally relevant to the fears and aspirations of our own time.

Our reappraisal must examine both the content of Mucha's work and its astonishing range. Mucha's fame rests on his mastery of an art form created for mass consumption and applied to adorn or promote utilitarian wares. Such art was long dismissed as merely 'decorative', more craft than art. But we have come in recent years to recognise that the best of Art Nouveau contains deep reservoirs of aesthetic expression and springs from a profound moral and inspirational intention.[4] In Mucha's case we are presented with a second body of work that continues in a different style the same essential idealistic message of his earlier creations. Finally, we have only recently begun seriously to appraise a third

part of his oeuvre, the Mucha pastels, works in a shockingly black and expressive mood that plumb the human dark side as sensitively as the famous Mucha woman celebrates its beauty and sensuality.

Mucha's Influences

MUCHA WAS BORN in 1860 in the Moravian village of Ivančice. His father was a court bailiff, a post at the lowest rungs of bourgeois respectability, the family residence shared the same building as the local jail. Mucha's daily acquaintance with poverty and suffering was reinforced by the death of three of his five siblings to tuberculosis. His mother was deeply religious, leading him on a pilgrimage at the age of seven. When he was eleven he entered the boys' choir at St Peter's Church in Brno, the nearby capital of Moravia. The mystical atmosphere of the mass, the resonant chanting and the richly symbolical decor and pageantry of the church deeply impressed him.

Moravia, like the rest of the Czech lands, had been under Hapsburg rule for hundreds of years. Domination by German political and religious authority had reduced the Czech language to little more than a peasant vernacular and had well-nigh obliterated indigenous Czech culture. In the 1860s the Czech National Revival, a patriotic and nationalistic effort to restore Czech culture and to gain autonomy within the political structure of the Austro-Hungarian Empire, was at its height. In Ivančice the revival was a keenly felt passion: a struggle to maintain a Czech-speaking school, to hold a seat on the town council and to celebrate Moravian ethnic traditions, including their exotic folk tales, colourful native costumes and whitewashed cottages adorned with highly stylised floral and botanic motifs.

From his earliest childhood Mucha was called to art. In the tradition of the Czech revival he understood the role of a true Czech artist to be both priest and patriot, to employ the direct emotive power of art to inform and uplift his people with a compelling expression of moral ideals. At seventeen he set out for Vienna where he found a job building theatre scenery. For the next seven years opportunity preceded disaster followed by greater opportunity yet as he trod where fortune led. To his sense of patriotic mission was added the belief that he was destiny's child. Life was theatre. If he remained true to his calling and to fortune's beckoning, great things lay before him.

In 1887 through the generosity of a patron, Count Khuen-Belasi, he moved to Paris to continue his studies and to make his mark in the world of art. Paris at the end of the 19th century was an extraordinary place at a remarkable time. The long deep recession that had followed the French defeat in the Franco-Prussian war in 1871 had at last been swept away by a vibrant economic recovery, renewed patriotism and a zest for the rebuilding of the nation and its culture. Overlaying all was an explosion of new technology, including internal combustion vehicles, electric lighting, aeroplanes, bicycles, voice recording, motion pictures and a variety of new manufacturing and productive processes. Nothing so exemplified the emerging age of commerce and technology as the Eiffel Tower, erected in Paris in 1889. No city had a better claim to being its locus and no idea so symbolised the new sensibility as Symbolism itself.

Among the Parisian avant-garde the doctrines of Symbolism led to a new concept of decorative painting. In our own times Decorative Art, and therefore Art Nouveau, has come to be viewed as mere ornamentation and thus ultimately superficial and insubstantial. But Decorative Art was conceived by its creators as the most profound means of artistic expression, by which ideals were to be intuitively conveyed to the viewer through symbolic and synthetic forms. And not just any ideals for the values of Decorative Art were highly mystical ones. The New Art was to be 'the first step in the journey to the true expressive synthesis' whose object was 'not only a particular idea, but also a universal idea, sublimated into the highest point of harmony, intensity and subtlety.'[5]

Thus, Decorative Art was intended to be nothing less than the expression in symbolic form of the highest and most abstract values of human life.

The centrality of idealism and mysticism to Symbolist thinking and to Decorative Art was linked to another trend in fin-de-siècle French culture: fascination with spiritualism and the occult. The fin-de-siècle was deeply preoccupied with a wide range of theosophies which expanded or supplemented Christian mysticism with spiritual messages thought to originate in Buddhism, Brahmanism, the Jewish Kabala and Egyptian, Greek and other ancient faiths. Spiritualists, mediums and psychics gained wide followings.

One further development also was crucial to the Symbolist foundation of the New Art. It is a fit reminder of the complexity and internal contradictions of Symbolism that this final influence sprang from a source that may appear to be directly at odds with the occult. During the last quarter of the 19th century important developments in theories of psychology suggested the possibility that art might be employed to influence viewers in ways not previously understood. Jean-Martin Charcot and others developed notions of the unconscious, the power of suggestion and the role of hypnosis. In social psychology Gabriel Tarde advanced the belief that the acquisition of consumer goods is strongly motivated by the purchaser's desire to acquire prestigious symbols, a choice made by consumers while in a somnambular state of semi-consciousness analogous to incomplete hypnosis. Taken together, the ideology of Symbolism, the aspirations of spiritualism and the methodology of visual hypnotic suggestion provided an integrated foundation for the creation of decorative objects whose highest function was to communicate, albeit unconsciously, idealistic visions to susceptible consumers.

Mucha received these avant-garde notions from several sources. Through his knowledge of the Pre-Raphaelites and the English Arts and Crafts movement and his associations with such artists as Paul Gauguin, Paul Sérusier and the Nabis, and the figures at the Salon des Cent and the avant-garde journal *La Plume*, he was well acquainted with the principles of Symbolism and its application by the leading artists of his day. Connections in the world of art inevitably spilt over into the occult. Acquaintances with August Strindberg, the astronomer Camille Flammarion, Colonel de Rochas of the Parisian Technical College and others led him to seances, experiments with extrasensory perception and spiritual suggestion and sessions of automatic handwriting. He participated in mystical societies, he joined the Freemasons. All remained with him for the rest of his life.[6]

Mucha capaciously absorbed the new influences of Symbolism,

spiritualism and hypnotic theory, the dynamism of Paris and of an art world in upheaval, and the new artistic possibilities presented by technology and commerce. These merged with his core values of religiosity, Czech patriotism and folk traditions, and his innate sense of theatre and destiny to form a truly new and in some ways unprecedented art.

Le Style Mucha

THERE WAS NO APPARENT REASON to expect such things of Mucha. It is true that he was a diligent and accomplished student, a gifted draughtsman and an astonishingly hard worker. It is also true that, faced with the loss of his patron's support and – as he later recalled – a starvation diet of lentils and beans, he managed successfully to support himself illustrating books and magazines, calendars and occasional posters, and designing theatre costumes. But in 1894, after seven years in Paris and then thirty-four years old, he had hardly distinguished himself from the throngs of aspiring artists struggling to find a niche in Paris. Precious little in his portfolio suggested that he ever would.

Then came Gismonda. It was a commission for a poster promoting a play featuring Sarah Bernhardt, the Divine Sarah, the reigning lioness of Parisian theatre, then in her prime. Depending on which story one credits, Mucha's triumph in garnering the commission sprang from the sudden and improbable intervention of divine Providence or was the result of a design competition. Either way, triumph it was and the result electrified Parisian society.

In our media-saturated age, ever more inured to ever more outlandish pitches in high-decibel stereophonic sound and high-density fluorescent colour, it is perhaps difficult to comprehend Gismonda's impact. By all accounts La Divine was enchanted, Paris was astonished and Mucha found himself an overnight celebrity.

The poster appeared on the Paris hoardings on or about New Years Day 1895. Since the late 1880s poster art had been well established in France through the work of Jules Chéret and others. By 1891 Toulouse-Lautrec had produced his brash and gaudy Moulin Rouge. Gismonda was radically different from anything that had come before. It was narrow and over two metres high. Placed on the hoardings, it presented a nearly life-size Sarah at eye-level with the viewer. Hers was an idealised, ethereal and finely wrought image, bathed in muted colours, her head framed by a halo. Sarah was so pleased that she signed Mucha to a six year contract. The public was so pleased that a market developed for purchase of the posters, a new development at the time. Those who couldn't or wouldn't buy them bribed the poster hangers for one or simply stripped them from the hoardings.

Gismonda was the first of seven posters for Bernhardt. It began a flood of commissions that inundated Mucha for the next decade. The demand for his creations was sustained by the distinctiveness and allure of an instantly identifiable style – le style Mucha – which became the hallmark of French Decorative Art. At the centre of his creations is the Mucha Woman. She beckons us hypnotically with some inexpressible yet compelling vision, some unspoken promise – wholesome, alluring, uplifting

and erotically vulnerable. Her gaze is half-focused, as if she is herself emerging, posed at the moment of awakening, suspended between her loving viewer and some faintly remembered image of another world. Her allure is often heightened by her tresses which spill luxuriantly, perhaps wind-blown or dishevelled, forming a halo surrounding her face. She is the antithesis of the morbid, effete and diabolical females who populate the contemporary works of Toulouse-Lautrec, Redon, Beardsley, Klimt, Denis and Gauguin.

Mucha's best Decorative works are finely wrought marvels of composition, often suffused with floral and other botanic elements and teeming with complex, highly repetitive, hypnotic structures of esoteric symbolic elements. For these Mucha employed Byzantine, Celtic, Japanese, Rococo, Gothic, Judaic and Czech folk elements involving mosaic backgrounds, gorgeous and extravagant robes and jewellery, arabesques, embellished with strong stylised outlines and interwoven with naturalistic detail. His work was compelling, often dazzling, sometimes disorienting and overwhelming. One only need look at such works as La Samaritaine 1897 or the dazzling pages of Le Pater 1899 to realise that one is in the presence of something new and extraordinary.

An important part of the creed of the Decorative movement was that art should be created for the masses and that it should serve to adorn and beautify goods of common consumption and utility. And so Mucha created his series of decorative panels, themed mass-produced works of art that could be afforded by the ordinary person, and in his design text book, Documents décoratifs, showed how the Decorative Art aesthetic could be applied to all manner of everyday objects. In fact his designs have been used over and again in connection with a variety of products around the world and down to our own times.

The spiritual systems that influenced Mucha believed that man is engaged in a long and painful struggle to raise himself from his benighted condition toward a divine, uplifted state. They also believed that this journey to emulate a heavenly ideal is supported by a divine presence, the 'great soul of the world', who mediates a higher wisdom to man, linking heaven with earth, the visible with the invisible, the eternal with the mortal. For man this mediation is symbolically embodied in light and expressed in art. To the artist initiated in these beliefs the purpose of art is not merely to present a pretty face or a charming scene but to convey a moral imperative by the direct impress on our minds of both explicit and hidden symbolic expressions. In recent years some students of Mucha who have carefully examined his influences and his creations have come to believe that this was his intent. In this view, the Mucha Woman embodies in anthropomorphic form the great soul of the world[7] and conveys, in part by hidden and unconscious archetypes, the knowledge that the universe is benevolent, that life is good and that happiness is within our reach if only we know how to grasp it. From this idealistic perspective, the application of Mucha's work to as many utilitarian devices and appliances as possible serves the moral purpose of disseminating the subliminal message to mankind as widely as possible.

Mucha's vision is unique among the art of his time. The Symbolist sensibility that so heavily influenced late 19th century art, including Decorative Art, combined large elements of

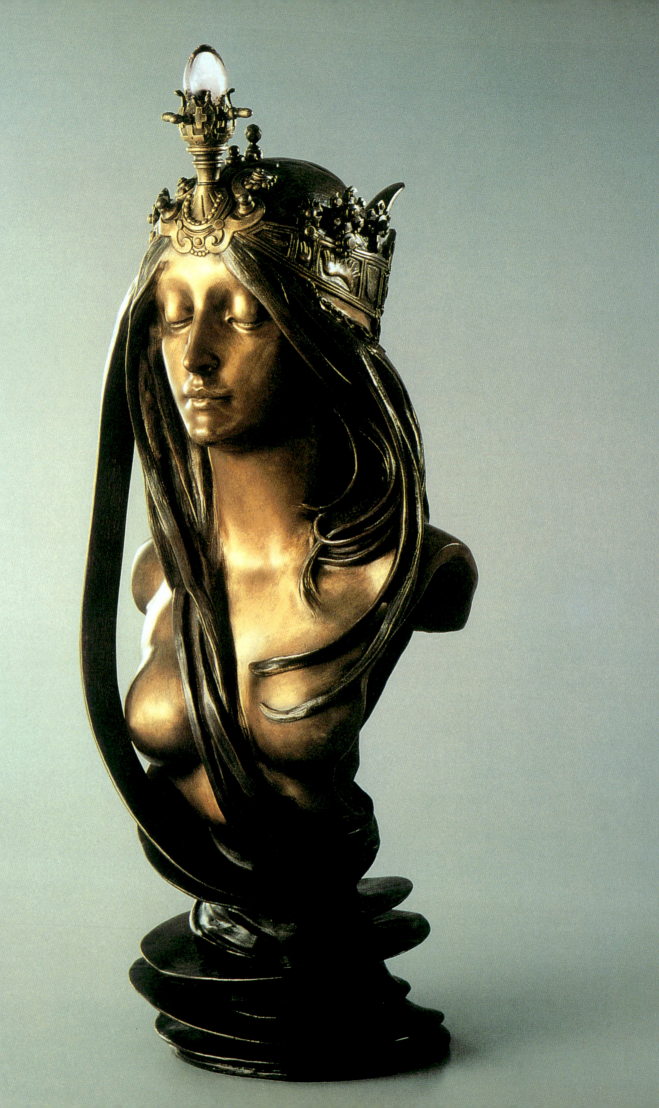

decadence, pessimism and dislocation. It was alarmed by the threat to the individual and to cultural traditions posed by science and technology, even while it adopted the new means that they provided for artistic expression. By the same token it was deeply uneasy over the materialistic society that technology spawned, even though it embraced the adornment and promotion of consumer goods to a degree never previously achieved. It also embodied a puritanical sense, no doubt inflamed by the rapidly changing role of women, that seated evil in women's irresistible sexual allure, personified artistically in the misogynistic image of the femme fatale. Its portrayals of the female were typically high-strung and uneasy, often hysterical, sometimes nightmarish and horrific.

There, in contrast, stood Mucha with his irrepressible optimism and vitality and the Mucha Woman who, nearly alone among the representations of female figures of the period, is neither demonic nor dissipated. Her glow of happiness and the hint of some hidden message, her suspension between this world and another, the integration in her person of Madonna and Venus, express a unique and joyous intuition. This quality is perhaps seen in its best and purest form in the remarkable sculpture, *La Nature* 1899. Mucha's insight, expressed through his art, may explain his popular appeal, an attraction that rests on more than the superficial harmony and warmth of the image. We know of Mucha's fascination with the occult and with hypnosis. Many of his best works portray figures lost in a hypnotic state, for example, the poster for the *6th Sokol Festival* 1912, or in a state of reverie, thus, *Salon des Cent: 20th Exhibition* 1896. Much of Mucha's work also involves a highly contrived, exotic, intricate and repetitive framing structure that has an undoubted suggestive and compelling power. Consider *Princess Hyacinth* 1911, *Zodiac* 1896, and the poster for *The Exhibition of the Slav Epic* of 1928. Can it be that through his intense studies and his total immersion in his art – we know that he sometimes painted in a trance – Mucha was in fact able to embed in his work some archetypal influences that speak their message to us *sub rosa*?

Mucha's highly spiritual and moral purpose during his Art Nouveau period is further shown in a small number of works on specifically spiritual topics. Among his most extraordinary creations is *Le Pater* 1899, a limited edition book, containing in pictorial and textual form Mucha's interpretation of the Lord's Prayer. The artistry represents Mucha at his best – finely wrought, detailed images and complex, sometimes hidden, geometric systems of symbolism. What is especially striking is how far his commentary and illustrations deviate from orthodox Christianity in favour of a neo-platonic spiritualism. The illustrations on the text clearly depict the striving of man toward the inspiration of divine light and the presence of idealised intermediating forms that are surely nothing less than the 'great soul of the world'.

The Pastels

DURING THE SAME YEARS that Mucha was producing his decorative masterpieces, he also explored a new style – unornamented, expressive and highly impressionist – in different media – pastel, charcoal and chalk. The pastels, as they are collectively known, have only recently begun to receive critical scrutiny. Some are clearly preparatory sketches, ultimately realised in other media and in his more familiar style. But many others appear to be works-in-themselves, representing a new and separate oeuvre that may prove to be among Mucha's most provocative and intriguing. Because the evaluation of the pastels is at an early stage, scholars differ in their opinions. Some regard the pastels as experiments in a style that Mucha later would abandon, others believe that they mark a moment of crisis in his personal life. More likely, they are the spontaneous products of his spiritual ruminations during the period when his aesthetic philosophy was still in formation. Some, *Couple with Light* c 1900 and *Vision* c 1900, clearly embody his notion of an intermediating spirit and

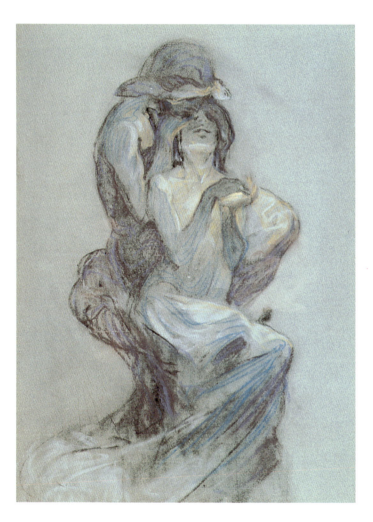

La Nature
1899

Couple with Light
c 1900

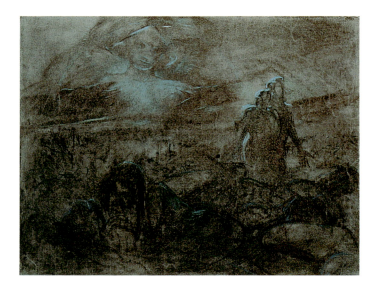

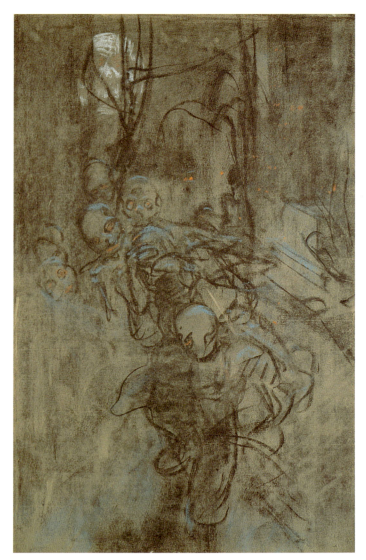

man's struggle for moral enlightenment. Others are scenes of unrelieved blackness and horror: *Phantoms* c 1900 and *Abyss* 1897. The notion that they are the private and personal chronicle of some moment of personal breakdown is belied by the fact that they span several of Mucha's most productive and successful years, that Mucha had in preparation a series of works to be publicly displayed on such themes as the *Seven Deadly Sins* and that the same introspective style appears in later Mucha creations on such topics as the horrors of war, *War* 1917. Whatever their source, the pastels are a powerful expression of Mucha's keen awareness of the shadow side – the existential pain of the human condition – of the inspiring hope that he held out for the potential of mankind's moral development.

The Birth of an Idea

IN 1899 MUCHA accepted a commission from the Austrian government to design the interior of the Pavilion of Bosnia-Herzegovina, recently annexed by Austro-Hungary, as part of his contribution to the Paris International Exhibition of 1900. To accept an Austrian commission springing from Slavic submission to Germanic rule was a problematic assignment for Mucha. He resolved it by transforming the interior into a celebration of southern Slav aspirations and folk traditions. Curiously the Austrian authorities acceded. In preparation for the assignment Mucha travelled widely through the Balkans researching their history and customs. From this experience sprang the inspiration for a new project that was to be the principal focus of the remainder of his career – the creation of a series of vast canvases that would portray the epic of the Slav peoples, a celebration of a mythic and idealised history that would emphasise their common bonds, their mutual reverence for peace and learning and their struggle against oppression.

This vast project – the *Slav Epic* – lay gestating in Mucha for three years. Finally, in the face of a continuing flood of commercial commissions, Mucha recognised that fulfilment of the project would require a serious alteration in his life, involving his full

energy for an extended period. This however presented a dilemma. For all the wealth and fame that Paris had showered on him, Mucha had never learned to hang on to his money. He was a pushover for friends down on their luck, struggling young artists and philanthropic causes. He kept his cash in a drawer; friends readily helped themselves. When the drawer was empty he replenished it. Friends also helped themselves to his suits, hats and whatever else they might lay their hands on. And Mucha himself led no hermit's life of self-denial. His Promethean capacity for work was matched by an appetite for dinner parties, theatre and the weekly salon that he sponsored in his studio for throngs of publishers, dealers, art lovers, writers, scientists, musicians and various celebrities. In a word, Mucha was without the means for his new undertaking.

In time he conceived a plan; it was vintage Mucha in its audacity and its implicit trust in destiny's favour. He would break with Paris, tour America gathering his nest egg from wealthy art patrons and return for good to the beloved homeland that he missed so badly, establishing himself in Prague to undertake the *Slav Epic*. He was perhaps encouraged by the example of Sarah Bernhardt, who more than once had retreated to America to renew herself when Europe had abandoned her, and by his American supporters, who assured him that commissions would fall to him like ripe fruit from the tree. Perhaps he also sensed that the wave

of Art Nouveau was ebbing as the avant-garde shifted their focus to other scenes. His decision was surely reinforced by his deepening involvement with Marie Chytilová, a beautiful Czech girl who was 22 years his junior and whom he would marry in 1906.

The American tour began auspiciously in the Spring of 1904 with a hero's welcome in New York. The 'world's greatest decorative artist' was the prize catch that season for every fashionable soiree, society's favourite as well as fortune's. It shortly devolved into disaster. None of his new and wealthy American friends imagined that Mucha was impoverished, he was not inclined to divulge his secret. He declined opportunities to undertake the decorative projects he did so well and famously, instead he accepted commissions for society portraiture. It was not his forte, assignments dragged on through years of endless fussing and repainting. Also he was unaccustomed to American business practices and not well advised. For the first time some of his work remained unsold. Other projects foundered on the insolvency or unreliability of his clients and associates. The dash for gold in America stretched to six extended tours over ten years, lost years during which artistic tastes moved ever further from his own and his memories of the homeland he had left many years before diverged ever more from the realities of the times. But in the end he was proved right. Fortune's favour appeared in the person of Charles Crane, an American millionaire who was intensely interested in foreign affairs and Slavic culture. Crane agreed to finance the *Slav Epic*, he was to provide financial and emotional sustenance to Mucha for nearly twenty years.

And so Mucha returned to Prague to take up the mission that was the capstone of his life.

The Return Home

AT THE TIME OF HIS RETURN Mucha had lived outside the Czech lands almost continuously for a quarter of a century. He had maintained a connection with his homeland through friendships with Czech colleagues, occasional visits with his family and, latterly, his new wife. He had also made frequent contributions to the Czech art world in the form of illustrations for Czech books and magazines, posters to promote Czech cultural events and designs for the new staging of the patriotic opera *Libuše*. One of his trips home had occurred on the occasion of Auguste Rodin's exhibition in Prague in 1902. He accompanied the celebrated sculptor during his reception in Prague and hosted him on a tour of the Moravian countryside.

In 1909 Mucha was invited to provide extensive interior decoration for Obecní dům, the Prague municipal building that had been under construction since 1905. He regarded it as a fine way to inaugurate his return to Czech society and, with typical generosity and enthusiasm, offered to do the work for his costs. The response, far from gratitude, was a firestorm of protest. The building itself was the object of criticism by the avant-garde, who regarded it as a relic of an outmoded style. That offence would only be exacerbated if it were to be decorated by a fading Parisian poster painter whose insidious offer would deprive younger and more needy local artists of important commissions. These complaints echoed earlier hostility that had arisen during the tour with Rodin when Mucha had urged Czech artists to break away from the model of Austrian art forms and develop a truly Czech

style. Rather than encouragement, his remarks were taken as criticism from one who had deserted his country for success abroad. It is a condemnation that Czech culture has visited on many of its most successful art figures, from Dvořák to Kundera, and it plagued Mucha for the remainder of his life.

In the end Mucha decorated only one chamber of Obecní dům, the Lord Mayor's Hall. He provided a series of dramatic and striking symbolic murals, evoking a mythic Czech past and imagining a glorious future for the country, including a ceiling decoration entitled *Slavic Concord* that foreshadowed the *Slav Epic*.

Mucha's Czech period spanned nearly thirty years. In addition to the murals and other decorations for Obecní dům, he completed a wide variety of other projects. Among them were numerous posters for cultural and charitable causes, illustrations for Czech magazines and books, the creation of elaborate historical pageants for Sokol, the Czech patriotic sports organisation, and a stained-glass window for St. Vitus Cathedral in Prague Castle. When Czechoslovakia became independent in 1918, he threw himself tirelessly into projects for the new nation, including the design of Czechoslovak currency and postage stamps and a new national emblem.

But the enduring project of the Czech years was the creation of the *Slav Epic*. As conceived by Mucha and his American benefactor, Charles Crane, the *Epic* was a series of twenty canvases to be presented as a gift to the people of the City of Prague. The project was monumental in both size and theme. Some of the canvases were as large as 6 by 8 metres. The series spanned more than a thousand years of Slav history, beginning with two scenes imagining a mythological past and ending with the *Apotheosis of the Slavs* 1926 which celebrates the final victory of the Slav people in their liberation from oppression. The canvases were completed between 1916 and 1926, although one of them was in fact never finished. They are divided equally between specifically Czech themes and those of other Slav peoples. They are also arranged thematically among allegorical, religious, military and cultural topics. All are highly emblematic scenes carefully selected for their moral content and didactic potential, the result of lengthy study by Mucha of Slav history and of extensive travel through his own country, the Balkans and Russia. And they are highly visionary in their technique, employing symbolistic figures floating disembodied in a metaphoric plane, while other figures anchored in the plane-of-being of the scene lock eyes with the viewer, engaging us directly in the space between contemplation and enactment.

At a superficial level the theme of the *Slav Epic* is threefold: it celebrates the Slavic virtues of peacefulness, piety and devotion to learning and the arts, it chronicles and laments the oppression suffered by the Slav people at the hands of more militaristic neighbours and it laments the weakness born of Slavic disunity. It is a continuation of the spirit of patriotic and national art seen in the works of the beloved Czech artists Josef Manés and Mikoláš Aleš. But in its concept, audacity and execution, the *Slav Epic* is an extraordinary achievement, in its own way as fresh and unexpected as *Gismonda* had been so many years before. There are, to be sure, variations in tone and style among twenty canvases created over nearly two decades and some may be deemed more successful than others. But taken as a whole the *Slav Epic* is an astonishing display of Mucha's stamina and

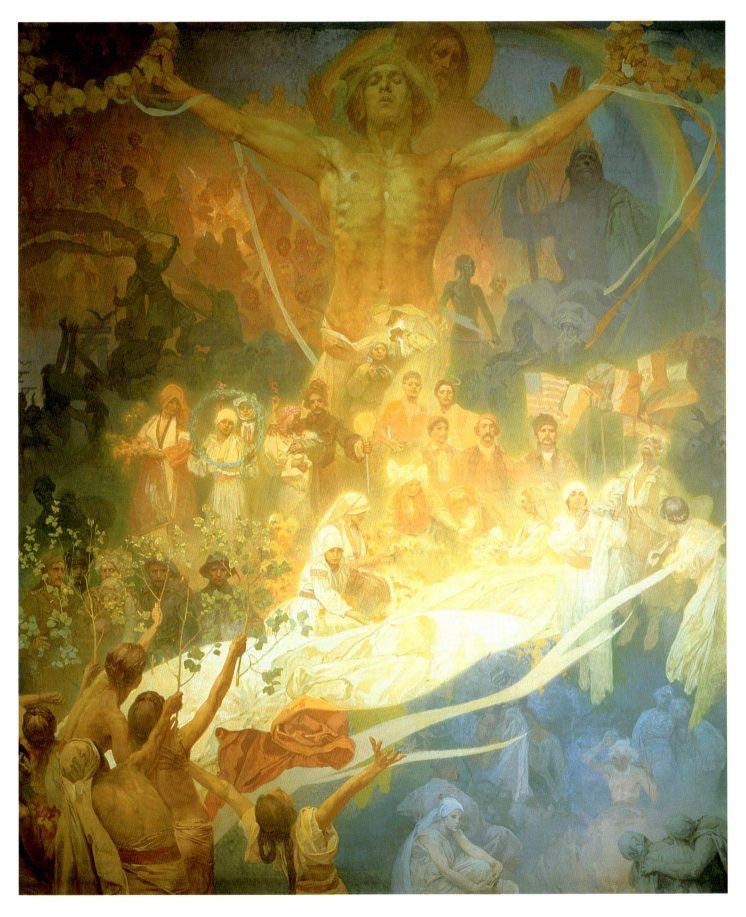

The Apotheosis of the Slavs
1926

dedication, marrying his talent for historical painting, his compelling use of symbolism and his mastery of the flat presentation and muted colours of his Decorative works. If he had done nothing more, this work should forever free him of the accusation of being a 'mere poster painter'.

The reaction to the *Slav Epic* in Czechoslovakia and abroad was a microcosm of Mucha's entire career. In 1919 the first five canvases were displayed in Prague's Klementinum. Attendance was huge and the public response appreciative. But critical opinion was indifferent or openly hostile. There were objections that the patriotic/historical theme was dated and resentment of Mucha's American (i.e. 'foreign') patronage. All or portions of the *Slav Epic* were shown in Czechoslovakia three more times during Mucha's life with the same response: increasingly admired and even revered by the common people, disdained by large segments of the artistic avant-garde and cultural elites.

The contrast with foreign attitudes toward Mucha could not have been more striking. Although the fashion for Art Nouveau, on which Mucha's fame abroad rested, had long passed, the taste for his work remained undiminished. In 1920-21 American exhibitions were held in New York and Chicago that included 5 canvases of the *Epic* as well as more than one hundred of his other works. Two hundred thousand visitors attended the show in Chicago, twice that number appeared in New York. Critical opinion was extravagant, the *Epic* was hailed as one of the great achievements of mural painting since the 16th century.[8] This was followed in 1936 by a retrospective exhibition at the Jeu de Paume in Paris of Mucha and his Czech contemporary, František Kupka. Mucha was represented by 139 works, including three canvases from the *Epic*. Once again the show was both a popular and critical success.

The American and French shows provided ample confirmation of Mucha's international stature but to little effect at home. In 1928 Mucha and Charles Crane officially presented the *Slav Epic* to the Mayor of Prague. Crane's patronage had stipulated that the city was to provide a suitable structure for permanent exhibition of the canvases. But the City provided neither exhibition space nor the prospect of providing one in the future and so, after the last temporary exhibition in 1933, the canvases were rolled up and placed in storage. They were to remain in storage for nearly thirty years until finally in 1962, through the prodigious efforts of residents of the Moravian village of Moravský Krumlov and the Mucha family, they were restored and placed on permanent exhibition. They have remained in that remote location ever since.

Mucha died on July 14 1939, in the aftermath of his interrogation by the Nazis. In the three decades since his return to his homeland, he had been continually dogged by vitriolic personal and artistic criticism and condemnation.[9] This was followed by silence. Throughout the war and the early Stalinist years after the Czechs' embrace of Communism, Mucha's work disappeared from the public scene. During the 1950s and 1960s, not a single showing of Mucha was held by the National Gallery, the principal repository of Czech art in Prague. In fact from the end of the war until 1990 only 10 of more than 700 exhibitions by the National Gallery included works by Mucha and most of those appearances were insignificant.[10] For much of that time a principal preoccupation of the Mucha family was to safeguard the *Epic* and his other art from confiscation and destruction.

Until the 1960s Mucha was largely missing from international exhibitions as well. But then, largely through the efforts of the Mucha family, the West again became exposed to Mucha's work. Between 1960 and 1980 Mucha's art appeared in six exhibitions in London, thirteen in Paris, six in Germany and two in the United States. Exhibitions devoted solely to Mucha were held in London, Paris, Zürich, Brussels, New York, Tokyo and other venues. Finally, in 1980, a Mucha exhibition was held in Prague but only after the show, sponsored in part by the Musée d'Orsay in Paris, had first appeared in Paris and Darmstadt. Remarkably the Prague exhibition was attended by over 200,000 visitors and may have been the most popular show ever staged by the National Gallery.[11] Once again the popular thirst for Mucha had survived years of official proscription. And once again the official attitude toward the *Slav Epic* remained dismissive, describing it as a 'tragic mistake' embodying a 'false mythology'.[12]

Since the events of 1989 Mucha has returned to avid attention in the West. But for the Czechs he remains a figure not yet fully reckoned with.

Why Mucha?

IN THE TRADITIONAL VIEW, Alphonse Mucha stands as a master of Art Nouveau, the Decorative style of lush and opulent adornment that briefly enraptured the fin-de-siècle world but passed from the scene as quickly as it erupted, supplanted by more worldly-wise and modern genres. For Mucha the decline of Art Nouveau was compounded by the consequences of his decision to return home. After 1938 Prague was largely isolated from the West and so therefore was much of Mucha's oeuvre. Disinterest abroad and disdain for him at home led to neglect and then a gradual amnesia about both the man and his art. For two generations neither critic nor art lover was likely to know of his creations, let alone ever see them. Mucha's avowedly spiritual works, his expressive pastels and the creations of his Czech years might just as well have never existed.

Insofar as his art was known, its reputation was problematic. To the modern eye Mucha's Decorative work might appear alternately charming, passé or even faintly kitsch. In so far as his other works were known, they seemed to provide repudiation of his Decorative creations from his own hand. His spiritual works, such as *Le Pater* 1899 and *The Beatitudes* 1906, were taken as expiation of his guilt over talent wasted in Decorative projects that were doubly faulted, being both commercial and lucrative. So too his pastels, such as *Abyss 1897* and *Absinthe* 1902, which express his dark and anguished broodings on human frailty, have been seen as manifestations of some inner turmoil, perhaps a further symptom of his angst over years wasted producing artistic ephemera for Parisian applause. And the creations of his Czech years, if they were known at all, were thought to confirm the judgment of him as a throwback to the 19th century, a zealot lost in lost causes of outdated nationalism and patriotic fervour.

But perhaps with the rediscovery of Mucha at our century's end and the discovery now for the first time of the full range of his creations, a fresh appraisal is possible and due. This reckoning must, of course, begin with a recollection of Mucha's core values. From the bosom of his Moravian childhood, he learned the lesson of art as ministry, a mission of enlightenment and inspiration

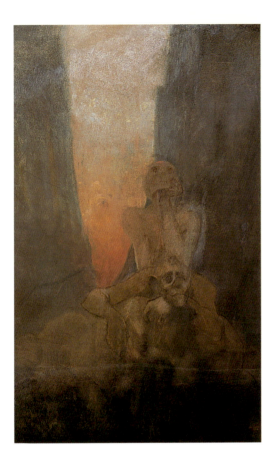

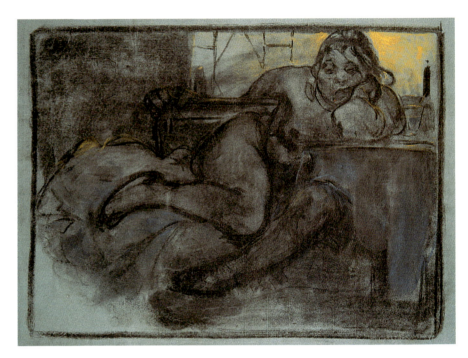

Abyss
1897

Absinthe
1902

whose beneficiary was the ordinary man and woman. His training in theatrical presentation and his Parisian immersion in Symbolism, mysticism and hypnotism reinforced and embellished his deep spirituality and provided him with new tools to fulfil his high purpose. This learning merged with two essential features of Mucha's character: his belief that he was destiny's child, charged with a calling and guided by a divine hand to fulfil it, and his prodigious capacity for work which he harnessed single-mindedly in the service of his art.

This new unitary conception of the man is a springboard for a new unitary conception of his art. We may now perceive with some confidence a common motive force that suffuses the best of all Mucha's work from the appearance of *Gismonda* in 1895 to the final triptych that followed the *Slav Epic* and occupied the last years of Mucha's life. Despite their variations in theme and style, all represent an attempt to use art in an idealised way to make a general metaphysical statement, to provide an inspirational portrayal of the nature of existence.

The first embodiment of this moral concept is the Mucha Woman. She comes to us again and again, not only in the Bernhardt posters, but also in *Zodiac* 1896, *Reverie* 1897, *The Moon and the Stars* 1902 and many other works. She beckons to us hypnotically, some amalgam of Moravian peasant maiden, Venusian goddess and blessed Madonna. In the spiritualist vernacular this idealised woman is the personification of a divine spirit, embodied in light, who mediates between the immortal and the mortal. Expressed in art she becomes the agent by which the divine message of hope touches the heart of man. Her presence is even more unmistakable in Mucha's explicitly spiritual work – for example in *Le Pater* 1899 which is filled with symbolist imagery.

But the spiritual message in Mucha's work is not limited to a

few special cases or to avowedly spiritual works. In the new learning that Mucha embraced, the powers of unconscious imagery and hypnotic suggestion allowed the whole range of consumer goods to become vehicles for speaking to impressionable consumers. Advertisements, decorative panels, calendars, biscuit tins and a huge range of other objects for everyday use became, in Mucha's hands, art dedicated to its highest moral use. Thus the general body of Mucha's decorative work from the Art Nouveau period can be understood, notwithstanding variations in its quality and occasional lapses into banality, as part of, not a diversion from, his essential purpose.

The same may be said for certain of Mucha's pastels which clearly are occupied with the same spiritual images that we have examined above. So too, those that focus on the miseries of human experience reflect the shadow side of Mucha's message of the benevolence of life.

In his Decorative period Mucha's focus was on the individual, the solitary female who beckoned from his posters to the solitary consumer of the wares that they promoted. With the commission to decorate the Bosnian pavilion for the 1900 International Exhibition, Mucha's attention was focused on the plight of the Slav people and the concept of the *Slav Epic* appeared to him. This spur undoubtedly triggered the patriotic impulse that had always been an elemental part of his nature. From that time the need to pursue this calling overcame all else. But it is astonishing that the creations of his Czech years should be viewed as a repudiation of his Decorative style. They reflect his virtuosity undiminished, in the same spirit and with the same mesmerising impact as before, and utilise to the end the symbolic feminine form to personify his moral ideal. *Princess Hyacinth* 1911, *Fate* 1920 and *The Age of Wisdom* 1936-38 demonstrate this continuity beyond disputation.

The *Slav Epic* and such other patriotic creations as the decorations in Obecní dům shift Mucha's focus from the individual to the collective. His evident intent is to inspire his countrymen with a symbolistic evocation of their past and invocation of their highest values. These works too have been misunderstood. Whereas his Decorative creations have been miscast as merely commercial, his patriotic efforts have been abjured as jingoistic. Mucha was a patriot but he was no chauvinist. Like his countryman and contemporary, Masaryk, Mucha believed in the destiny of nations and sought to spur his nation to fulfil its destiny by appealing to what he conceived as its best and highest innate virtues. But this belief was only the specific application of a general principle. On the completion of the *Slav Epic* in 1928 Mucha said, 'I am convinced that the development of every nation may proceed with success only if it grows organically and continuously from the nation's own roots and that for the preservation of this continuity knowledge of its historical past is indispensable.'[13] He lived as he spoke. During his American tour at the height of his great success, lecturing as a renowned European artist, he passionately urged his audiences to avoid imitation of even the best European art in order to develop an authentically American aesthetic.

As he believed about art so did he about life. At the pinnacle of his Parisian success Mucha drank in life with inexhaustible energy and enthusiasm, producing an astonishing variety and quantity of work, relishing the culture of his new age and generously befriending colleagues and countrymen often to his own impoverishment. In America and on his return home he continued with the same conviction and generosity of spirit. He persevered for nearly thirty years after his return to Prague, pouring himself into innumerable public and humanitarian causes, labouring over the massive canvases of the *Slav Epic* and persisting in the face of unceasing disdain for his art and criticism of his values. At the end of the 1930s as he looked back upon a life span of nearly 80 years, the Decorative art that had been the fount of his fame and glory had all but disappeared from the public scene, the patriotic values that he held so passionately had become an anachronism and the great *Epic* that had been the capstone of his life lay rolled-up in a dank museum basement, homeless and largely forgotten. His personal misfortune was compounded by the knowledge that his nation seemed on the cusp of losing its newly-won freedom, apparently destined to return to German rule of a Nazi hue and to the agony of another great war. At that moment he was engaged in studies for his final project, a monumental and celebratory triptych, *The Age of Reason*, *The Age of Wisdom* and *The Age of Love*. It was the ultimate expression of the benevolent and optimistic faith that had guided his life. The three panels portrayed in a highly symbolistic style a world in which the forces of reason and love were brought into harmony by the influence of wisdom. In the centre, embodying wisdom and lighting the way for striving humanity, was the radiant feminine form of the great soul of the world. The circle of Mucha's loving vision had enlarged, undiminished by the disappointments of the years, beyond the Mucha Woman, beyond his beloved people, to embrace all mankind. To those who ask, 'Why Mucha?', that is why.

FOOTNOTES

1 Portions of this essay are based upon material that has previously appeared in Ronald F. Lipp and Suzanne Jackson, *The Spirit of Mucha* in *Alphonse Mucha: The Spirit of Art Nouveau*, Art Services International, Alexandria, Virginia, 1998. The author gratefully acknowledges the extensive research by Ms Jackson which made the present essay possible.

2 Debora L. Silverman, *Art Nouveau In Fin-de-Siècle France*, University of California Press, Berkeley and Los Angeles, California, 1989.

3 Julia King, *The Flowering of Art Nouveau Graphics*, Peregrine Smith Books, Salt Lake City, 1990.

4 Growing recognition of Mucha's importance in the artistic pantheon was recently provided in a survey of Art Nouveau by Jeremy Howard, who said: '[Mucha] was the embodiment of the Art Nouveau synthetist practising almost all the arts, including architectural design and photography, fusing the spiritual with the material, fine with commercial art, socialism with elitism, the ideal with the real, the universal with the national, the eastern with the western, Christian with the pagan, the ancient with the modern. All in a quest for the beautiful.' Jeremy Howard, *Art Nouveau, International and National Styles in Europe*, Manchester University Press, Manchester and New York ,1996, p. 19

5 Dr Petr Wittlich, *The Message of Mucha*, The Catalogue of the Alphonse Mucha Exhibtion at the Prague Castle 1994, p. 18, quoting in part from J. Peladan: *La Decadence esthetique, L'Art ochlocratic, Salons de 1882 et de 1883* Paris 1888. Dr Wittlich's essay, together with his later exposition, *Alphonse Mucha, the Person and his Work*, The Catalogue of the Alphonse Mucha Exhibition at the Calouste Gulbenkian Museum, Lisbon 1997, are seminal works in their analysis of the Symbolic and mystical influences on Mucha and of their embodiment in his Decorative works and pastels.

6 The importance of spiritualist and occult influences on Symbolist art and Mucha's work in particular is examined at length in Victor Arwas, *Le Style Mucha and Symbolism* in *Alphonse Mucha: The Spirit of Art Nouveau*, Art Services International, Alexandria, Virginia, 1998, and Derek Sayer, *The Coasts of Bohemia*, Princeton University Press, Princeton, New Jersey, 1998.

7 The first published essay identifying the Mucha Woman as an embodiment of the great soul of the world apparently is Wittlich, *The Message of Mucha*, supra, note 5.

8 Jiří Mucha, *Alphonse Mucha, His Life and Art*, Heinemann, London, 1966, pp. 270-71, 273.

9 In 1913, the Czech poet and later Communist cultural icon S. K. Neumann, called for 'Death To...' among other things, Alphonse Mucha. In 1919, Neumann called the *Slav Epic* 'a sugary monstrosity of spurious artistic and allegorical pathos' and 'a crime against the Holy Spirit'. The history of the treatment of Mucha by the Czech artistic and cultural communities is documented in Anna Dvořák, *The Slav Epic* in *Alphonse Mucha: The Spirit of Art Nouveau*, Art Services International, Alexandria, Virginia, 1998, and Derek Sayer, *The Coasts of Bohemia*, Princeton University Press, Princeton, New Jersey, 1998.

10 Sayer, supra, p.250.

11 Sayer, supra, p. 249.

12 *Alfons Mucha: 1860-1939*, Jízdárna Pražského hradu, září-listopad, Národní galérie, Prague, 1980, pp. 33, 95.

13 Translation from Sayer, supra, p. 350, n.257.

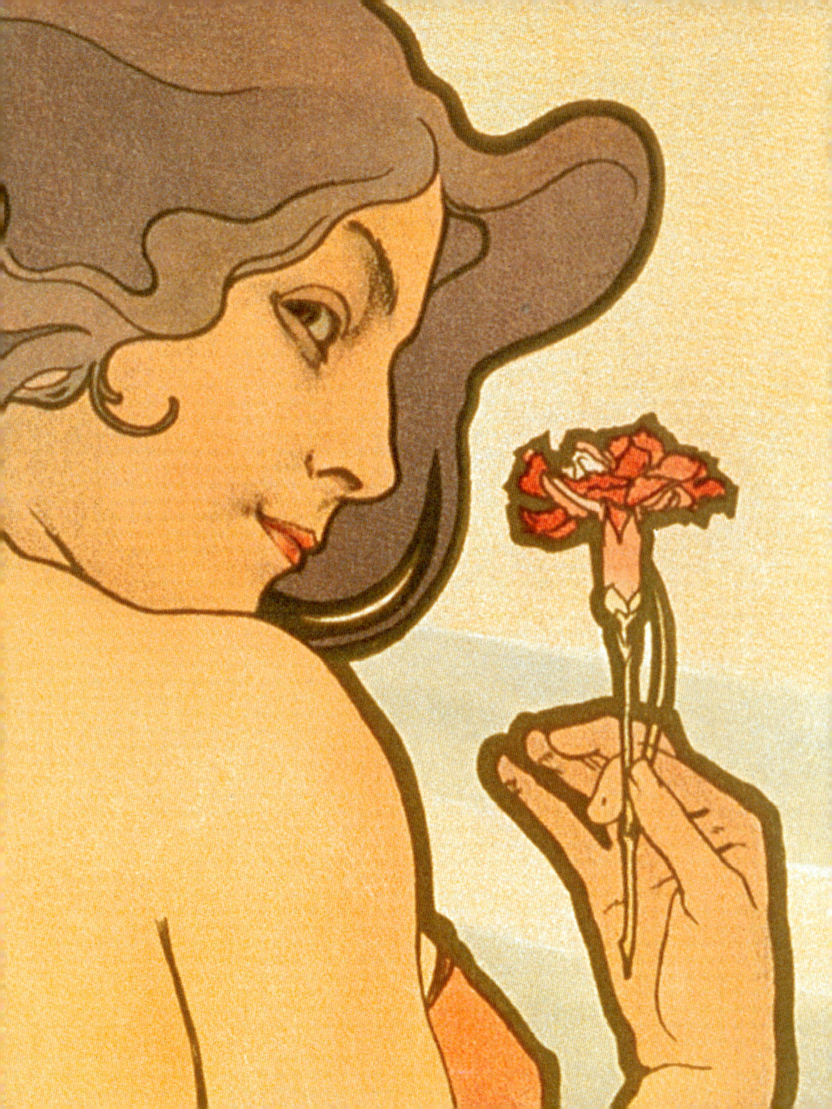

MAÎTRE DE L'AFFICHE

DECORATIVE PANELS

by Petr Wittlich

THE ART NOUVEAU MOVEMENT, of which Alphonse Mucha was a major exponent, was concerned with the development of decorative schemes based on the repetition of stylised patterns that could be used for ornamentation. For Mucha the starting point was always the subject of the image. It was important that the subject should lend itself to the creation of a coherent set of images based on traditional themes, usually drawn from the natural world. Thus, Mucha's first decorative panels, produced in 1896, took the four seasons as their theme.

Mucha continued to produce works in this fashion, making either two or four variations on a variety of themes, in a series of exceptionally successful decorative panels. Mucha's decorative style was most fully developed during this period, with the creation of works such as *The Flowers* 1898 and *The Times of the Day* 1899. The combination of both highly stylised botanical elements and beautiful women was the expression of a joyful vision of life, one greatly appreciated by the viewer of the time.

From an artistic point of view, the series *The Arts* 1898 is considered the most significant. There are several variants in different media, and the series is distinguished by the poetic quality of Mucha's designs.

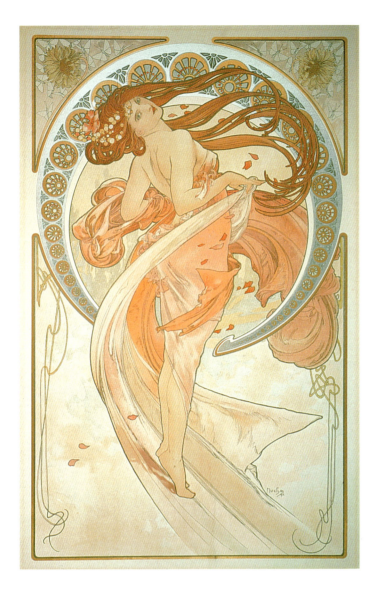

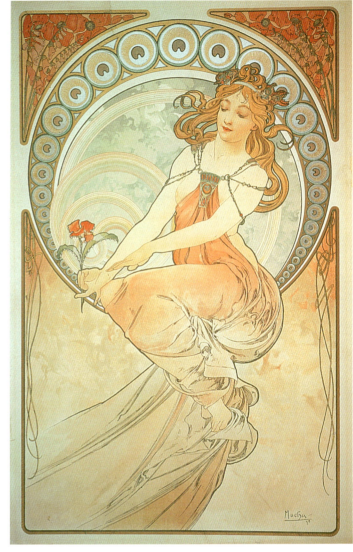

Dance
1898
colour lithograph
60 x 38

Painting
1898
colour lithograph
60 x 38

The Arts

1898

In his series celebrating the arts, Mucha dispenses with the use of traditional attributes such as quills, musical instruments or drawing materials. Instead he emphasises the creative inspiration of natural beauty by giving each of the arts a natural backdrop relating to a time of the day: for *Dance* falling leaves blown by a morning breeze, for *Painting* a flower lit by the midday sun, for *Poetry* the contemplation of the countryside as the evening star rises and for *Music* the song of the birds at moonrise.

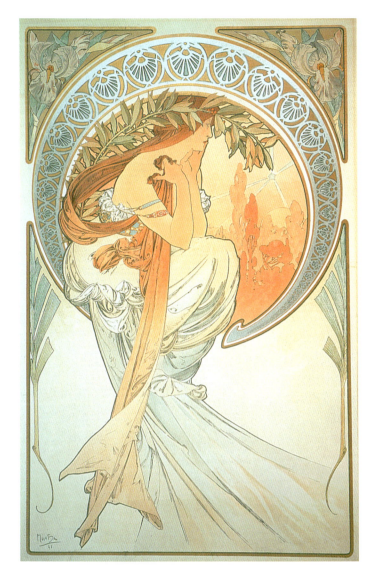

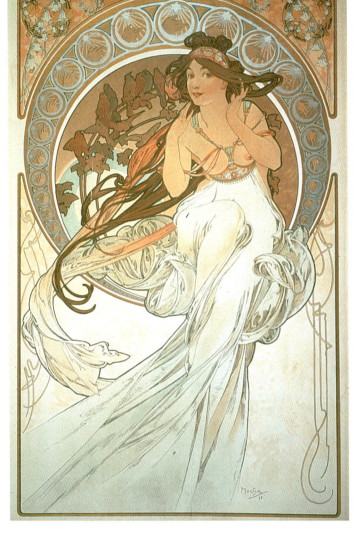

Poetry
1898
colour lithograph
60 x 38

Music
1898
colour lithograph
60 x 38

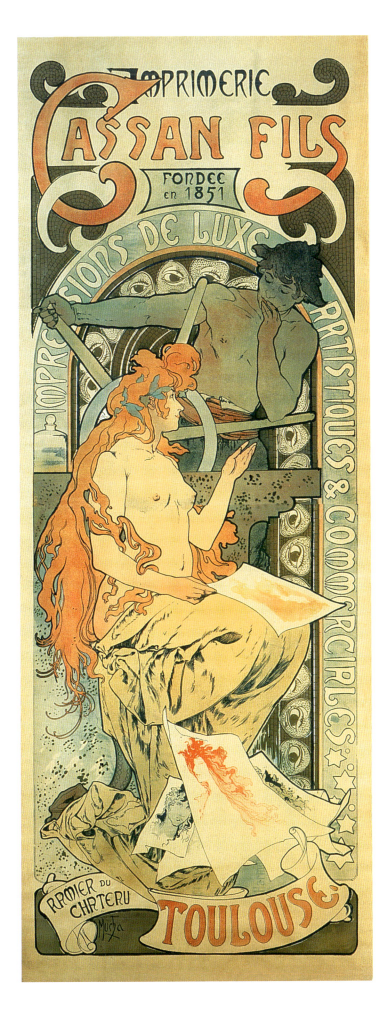

Cassan Fils
1896
colour lithograph
203.7 x 76

In this poster for the Cassan Fils printing works Mucha combines the real with the emblematic – the semi-naked model is a real person whereas the faun-like printer is allegorical, representing the printing industry. The border of eyes in the mosaic background may be intended to represent the many readers who benefit from the printing works.

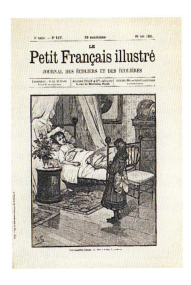

**Le Petit Français illustré
Journal des écoliers et des écolières**
1890-95
lithograph
38.2 x 28

The commission from the publishing house of Armand Colin to produce illustrations for *Le Petit Français illustré*, a magazine which featured stories by popular authors, inexpensively and generally rather badly illustrated, was a turning point for Mucha. In 1889 the young editor, Henri Bourrelier, was looking for a new illustrator. He sought out Mucha in his freezing room in the Latin Quarter and found him in bed, penniless, hungry and ill. He immediately obtained an advance for Mucha from Mr Colin, ordered some illustrations and sent a doctor to his room. Within a few days Mucha was well enough to work on the commission. On the strength of his work for *Le Petit Français illustré*, Mucha was offered further commissions both by Armand Colin and by other book and magazine publishers. Henri Bourrelier remained a life-long friend.

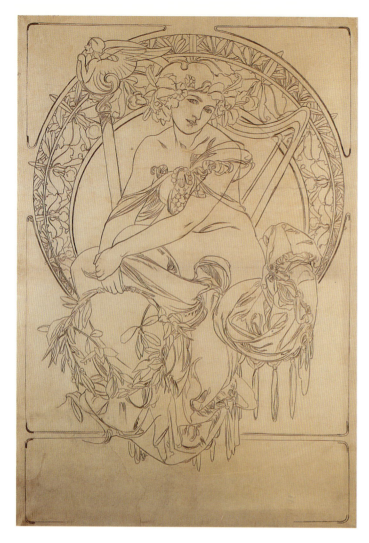

Design for musical poster
c 1900
charcoal on paper
150.7 x 100.4

Ilsée, Princesse de Tripoli
by Robert de Flers
L'Edition d'art, H. Piazza et Cie, Paris
1897
book illustrated by Alphonse Mucha
30.1 x 24.2

In 1895 Sarah Bernhardt produced and starred in *La Princesse Lointaine*, written for her by Edmond Rostand. The freshness of Rostand's writing, the novelty of Mucha's designs and Sarah's affecting portrayal of the heroine, Mélissinde, combined to make the production a huge success. Henri Piazza, an enterprising publisher, decided to publish the play in an expensive edition with drawings by Mucha.

Rostand's excessive financial demands, however, sent the publisher in search of another author, Robert de Flers, to rewrite the story. By the time de Flers had completed his manuscript, there were only three months left before *Ilsée* was due to be published and Mucha still had to draw and prepare 134 coloured lithographs for press. There was no time for rushing backwards and forwards from printing house to studio – instead Mucha moved into a larger studio and did much of the lithographic work on the spot. He later wrote of the experience: `We worked on four stones simultaneously. I did some of the drawings straight onto the stone. Other things, particularly the decorative edgings, I drew on tracing paper which was then passed on to the draughtsmen who continued the work with the colours I specified. I hardly had time to sketch out the motif for an ornament when they came and took it from my hands and got down to work on it.'

The book was published as a limited edition of 252 numbered copies. Mucha designed the whole book and decorated every page.

It is interesting to note that it was in *Ilsée* that Mucha first developed his practice of drawing personifications of spiritual or natural powers to a larger scale in order to accentuate their protective role. Also in *Ilsée*, Mucha's ornamentation begins to take on a more deliberate symbolic meaning, with motifs derived from theosophical and Masonic themes.

Ilsée was given an enthusiastic reception by the critics. Czech and German editions were later published in 1901 in Prague by B. Koci.

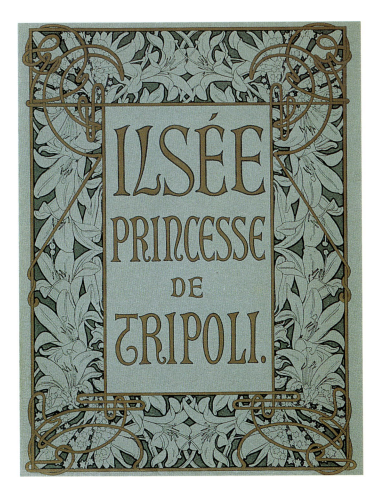

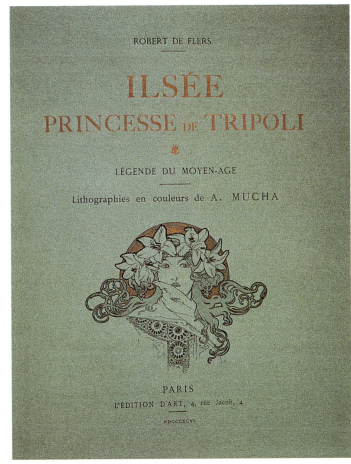

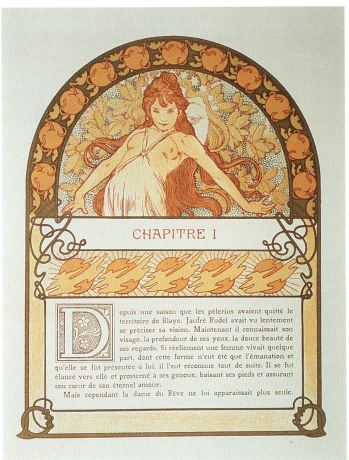

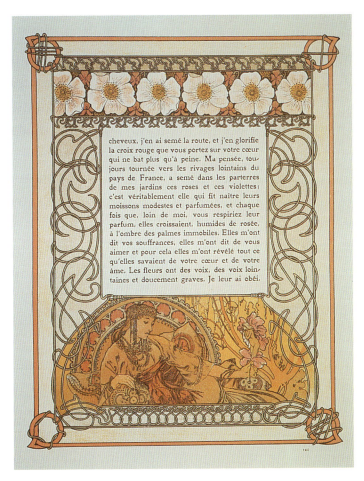

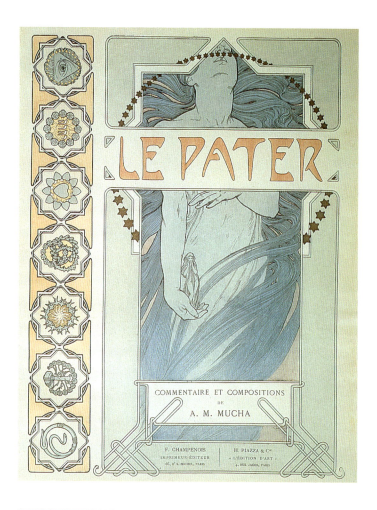

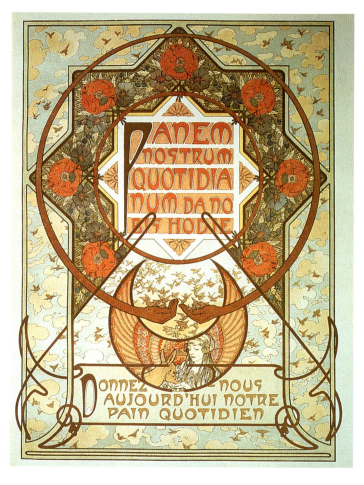

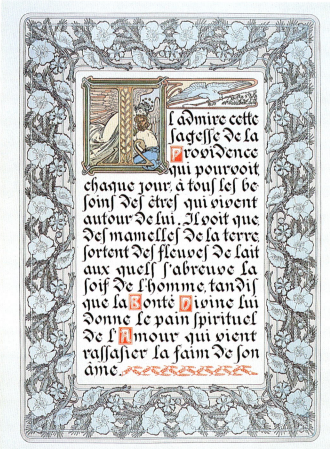

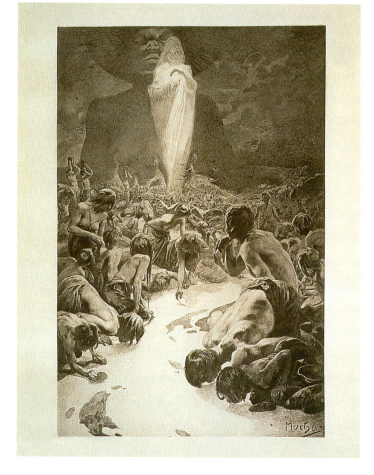

Le Pater
H. Piazza et Cie, Paris
1899
illustrated book
33 x 25

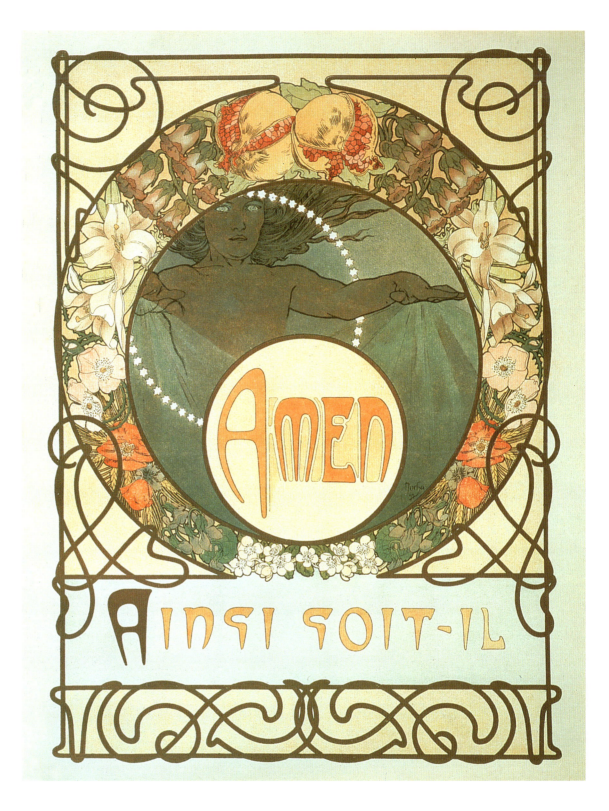

Mucha considered *Le Pater* among his finest works. It was printed in Paris in an edition of 510 numbered copies (390 French and 120 Czech) by Henri Piazza, to whom Mucha dedicated the work.

Mucha wrote of *Le Pater*: 'At that time I saw my path as lying elsewhere, somewhat higher. I was looking round for a means to spread light that would reach even into the remotest corners. I did not have to look long. The Lord's Prayer. Why not give its words pictorial expression?'

In *Le Pater* Mucha divides the prayer into seven verses. He analyses each verse in a set of three decorative pages. On the first page, in colour, he presents the verse in Latin and French surrounded by a decorative composition which incorporates geometric and symbolic motifs. On the second page, Mucha gives his commentary on the verse, emulating a medieval illuminated manuscript in the decoration of the coloured initial letter. The third page is a monochrome pictorial representation of Mucha's commentary. These visionary illustrations represent man's struggle as he journeys from darkness to light.

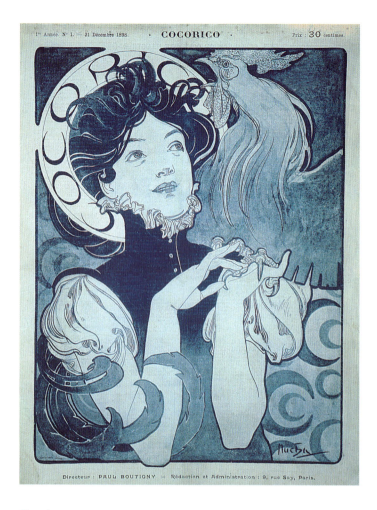

Cocorico
magazine cover No. 1 December 1898
lithograph
31 x 24

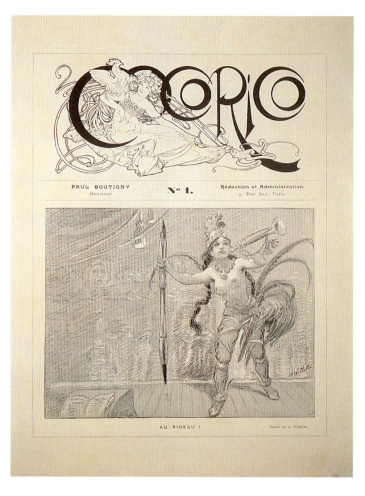

Cocorico
Frontispiece for the magazine
(below **Au Rideau** by A. Willette)
1898
lithograph
31 x 24

Cocorico

1898-1902

Mucha executed designs for a wide variety of magazines
throughout his life, in France, the United States and
Czechoslovakia. One of his most productive collaborations was
with the French magazine *Cocorico*, an illustrated satirical
magazine which supported the new art and whose covers were
designed by foremost artists of the movement. Mucha worked
with the magazine from its first issue which was published on
December 31 1898. He was commissioned to design the
frontispiece for all issues, a number of covers – some of which
were later made into postcards by Champenois – and a series of
symbolic drawings on the theme of the twelve months.

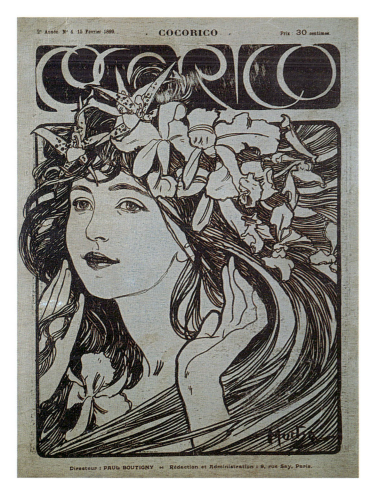

Cocorico
magazine cover No. 4 February 1899
lithograph
31 x 24

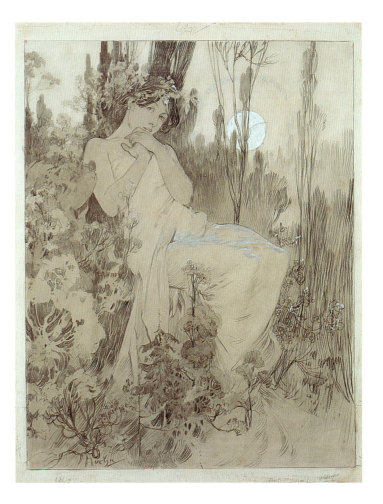

Cocorico
June from **The Months**
1899
pencil and wash drawing with white on paper
40 x 32

DESIGNS FOR LA BELLE ÉPOQUE

As THE 19TH CENTURY drew to an end, Mucha began to develop his talents as a designer. His designs covered a wide range of objects – everyday domestic items, jewellery, furniture and sculpture, both small and large scale. His most ambitious design project, the *Pavilion of Mankind*, which was planned for the Paris International Exhibition 1900, was never realised. It is difficult to assess whether this was a loss to mankind or not, since its construction would have demanded the dismantling of the Eiffel Tower down to the first platform, which would then have been used to support a building of colossal dimensions, adorned with gigantic statues and topped with a globe. Despite the loss of this project, Mucha was kept very busy by the International Exhibition. His main project was the decoration of the Bosnian Pavilion. He also designed jewellery for the stand of Georges Fouquet and a statue for the Houbigant stand.

As Mucha became well known as a designer he found himself more and more in demand to produce designs for jewellery, cutlery and tableware, tapestry etc. He therefore conceived the idea of creating a 'handbook for craftsmen', which would offer all the necessary patterns for creating an Art Nouveau lifestyle. *Documents décoratifs*, which was published in 1901 by the Librairie Central des Beaux-Arts in Paris, is an encyclopaedia of his decorative work. It leads the student through the process of stylisation from a realistic study of nature to a finished product in metal, leather, glass or lace. It was sold to schools and libraries throughout Europe.

Documents décoratifs was so popular that a further publication was produced three years later. *Figures décoratives* is mainly dedicated to the use of the human body as a decorative element.

Poster for
Documents décoratifs
1902
colour lithograph
75.5 x 44.9

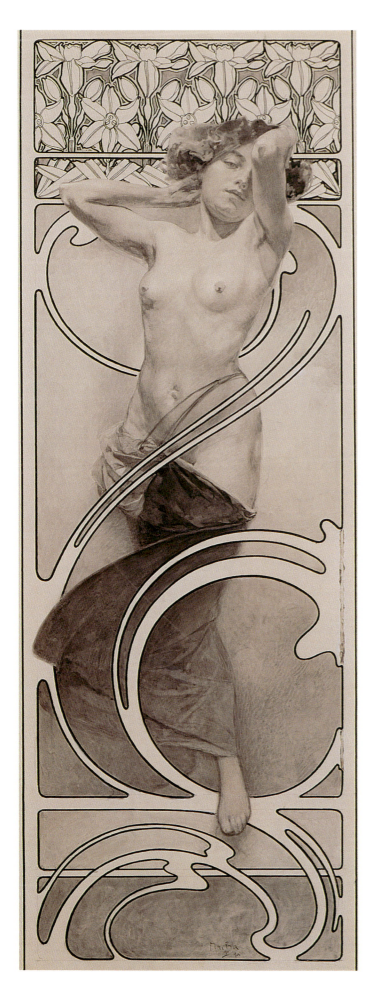

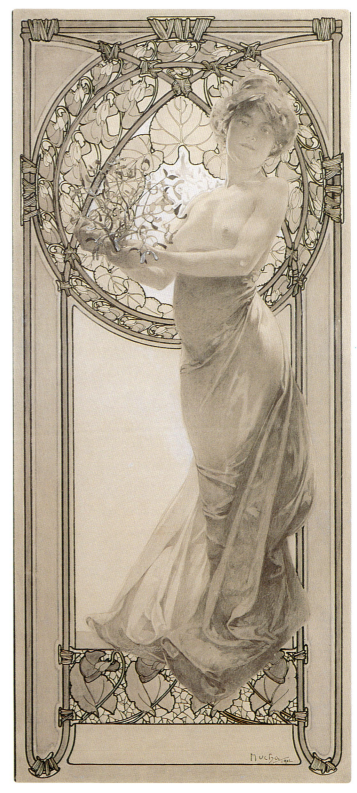

Nude within a decorative frame
Design for Documents décoratifs
Plate 10
1902
pencil, indian ink and white on paper
61 x 23

Woman holding Mistletoe
Design for Documents décoratifs
Plate 11
1902
washed indian ink and white on paper
61 x 28

Documents décoratifs
Study of rowan berries
c 1901
pencil on paper
47.7 x 31.2

Documents décoratifs
Study of lime leaves
c 1901
pencil on paper
47.7 x 31.2

Two standing women
Design for Documents
décoratifs Plate 45
1902
pencil, pen and indian ink
on paper
62 x 47.5

DOCUMENTS DÉCORATIFS
by Petr Wittlich

In 1902 MUCHA PUBLISHED *Documents décoratifs*, a collection of 72 plates drawn in pencil and highlighted with white pigment which presents samples and patterns in the new style for designers in the field of arts and crafts. The portfolio also contains a variety of ornamental and naturalistic floral motifs, studies of women's heads and nudes, combining illustrative naturalism with abstract ornamental framing.

The designs for jewellery, furniture, tableware and other objects pertaining to the everyday domestic life of the period indicate that Mucha's purpose in creating this volume was twofold. On the one hand, he was cataloguing the enormous range of his experience in working in the decorative field, an experience that extended beyond the two-dimensional drawn surface into the three-dimensional space as is shown in his work for the Paris International Exhibition of 1900 and the magnificent gilded interior of the Fouquet boutique. On the other, he was aiming to express the definitive visual statement of the new style. Even considering the fact that at this advanced date the Art Nouveau era was essentially fading into memory, one has to admire Mucha's masterful draughtsmanship and his ability to create a unified style, transforming the material world into elegiac and idealised shapes permeated with the power of natural growth.

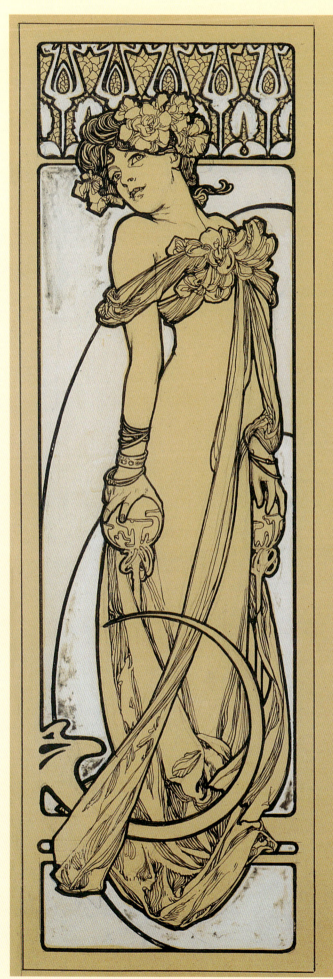
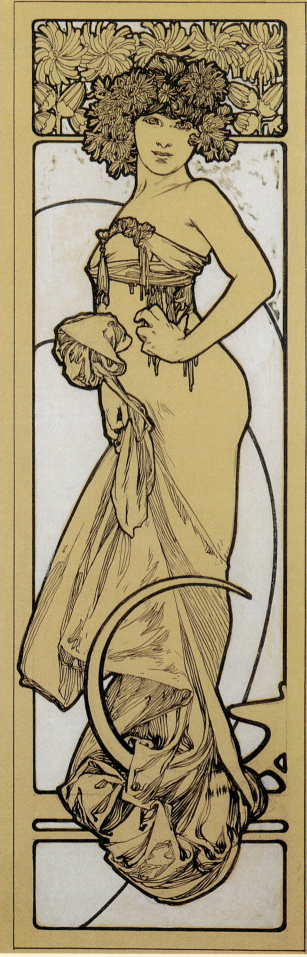

Documents décoratifs
Plate 46
1902
colour lithograph
46 x 33

Documents décoratifs
Plate 29
1902
colour lithograph
46 x 33

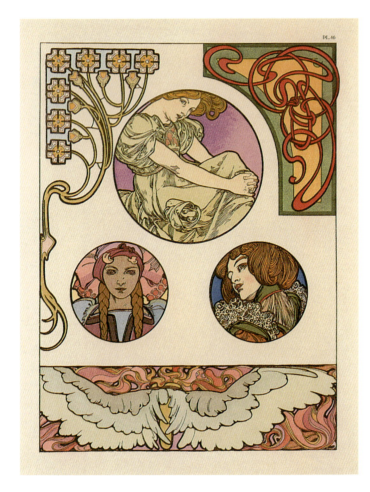

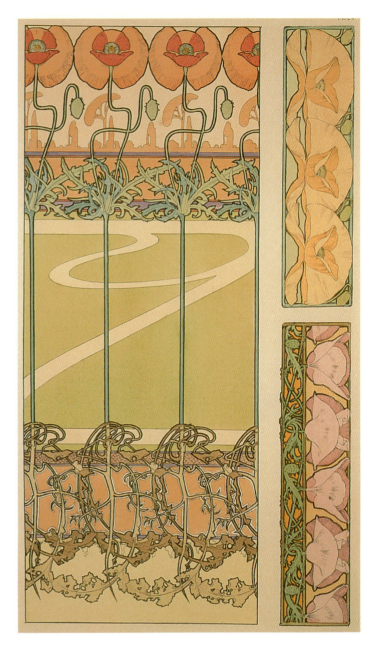

Documents décoratifs
Plate 38
1902
colour lithograph
46 x 33

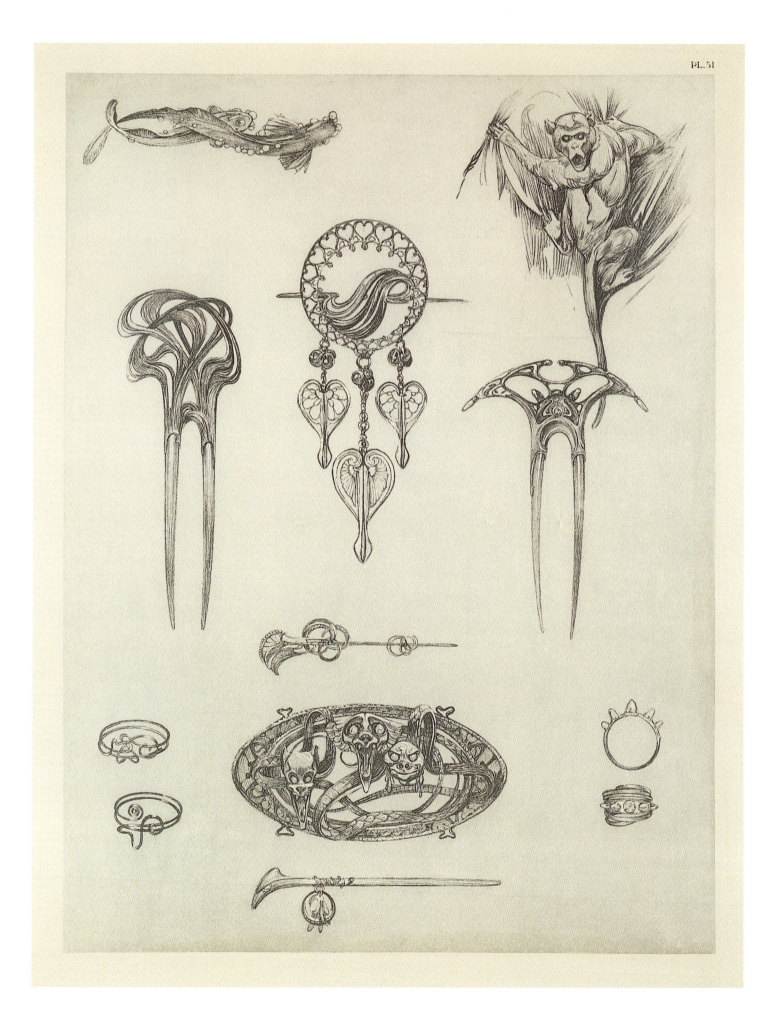

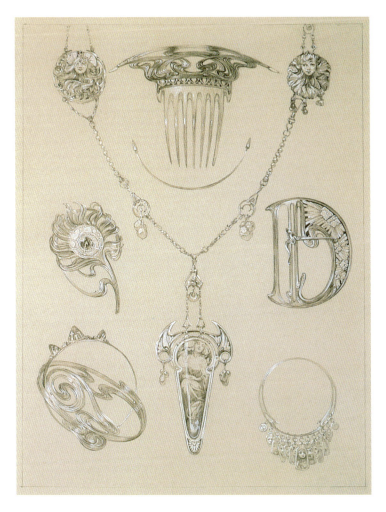

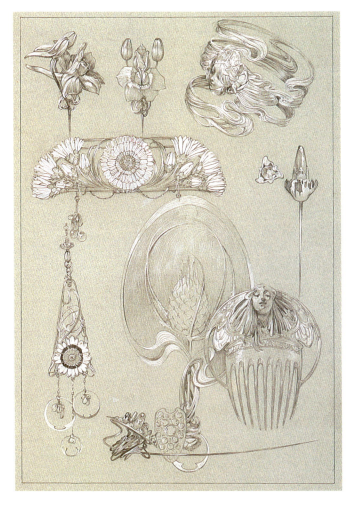

Design for Documents décoratifs
Plate 49
1902
pencil and white on paper
51 x 39

Design for Documents décoratifs
Plate 50
1902
pencil and white on paper
50.5 x 39

Documents décoratifs
Plate 51
1902
lithograph
46 x 33

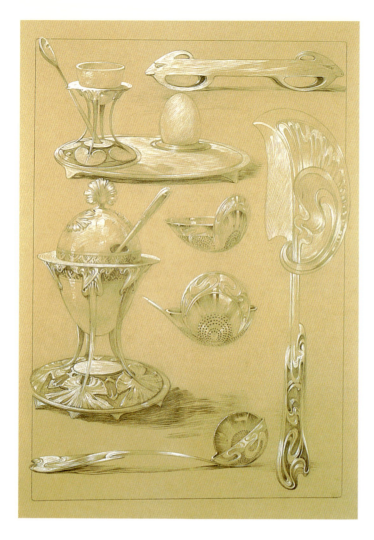

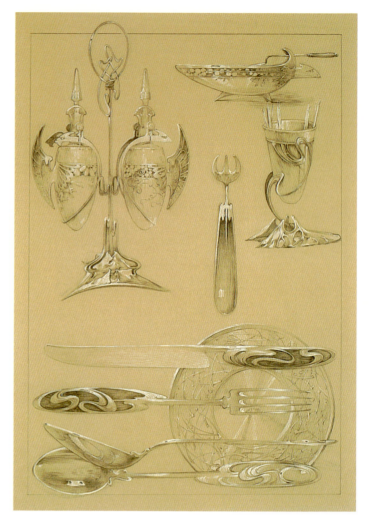

Design for Documents décoratifs
Plate 65
1902
Pencil and white on paper
53 x 40

Design for Documents décoratifs
Plate 69
1902
pencil and white on paper
60.5 x 45.5

Documents décoratifs
Plate 64
1902
lithograph
46 x 33

Documents décoratifs
Plate 71
1902
lithograph
46 x 33

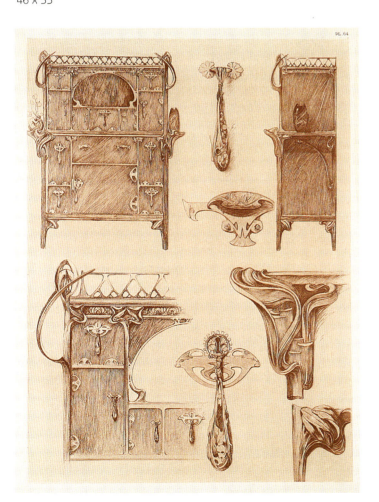

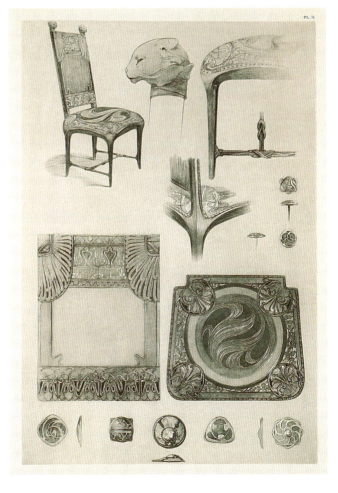

Documents décoratifs Plate 70
1902
lithograph
46 x 33

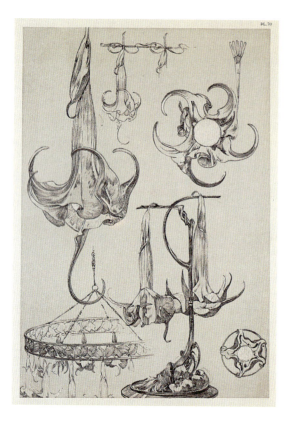

Documents décoratifs Plate 34
1902
lithograph
46 x 33

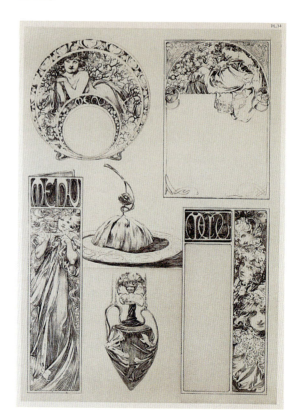

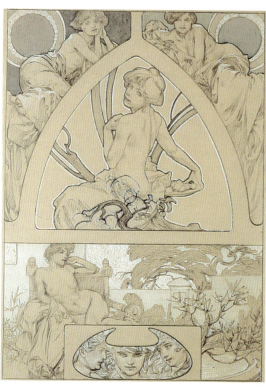

Nudes within a decorative frame
Design for Figures décoratives Plate 4
1905
pencil and white on paper
62 x 47.5

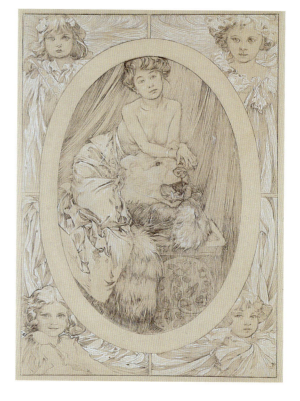

Woman on a bear skin
Design for Figures décoratives Plate 9
1905
pencil and white on paper
62 x 49

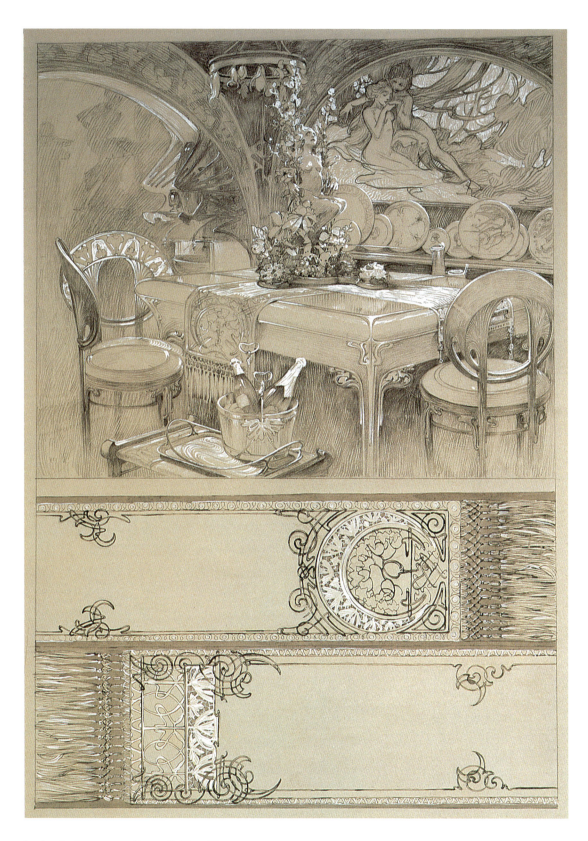

Design for Documents décoratifs Plate 72
1902
pencil and white on paper
52 x 39

**Metal tin with lid and handle
for Biscuits Lefèvre-Utile**
1899
print on metal
16 x 13.5 x 11.5

Biscuits Lefèvre-Utile, a biscuit company based in Nantes, commissioned many artists to create publicity material for them. Mucha was one of their regular artists. He produced many designs, including several posters, box tops and paper wrappers for biscuit tins. He also designed two metal tins, a rectangular one and this circular one.

**Decorative plate with the symbol of
the Paris International Exhibition**
1897
porcelain
diameter 31 cms

This porcelain plate, made in France, is decorated with the seated figure of a woman. She holds a statuette of a woman holding high a victory wreath, the emblem of the International Exhibition in Paris in 1900.

The outer ring of the plate represents a frieze of fleur-de-lys, the symbol of the kings of France. They are interconnected and slightly flattened. The inner ring carries alternate images of the double headed eagle, the symbol of the Austro-Hungarian Empire.

Head of a Girl
1900
bronze, silver and parcel gilt
29 x 10 x 22

Mucha designed this sculpture for the display of the famous perfume manufacturer Houbigant at the International Exhibition in 1900. Although the form of the sculpture is derived from Renaissance works, the technique and high finish, creating striking effects of colour and light, are typical of contemporary craftsmanship. In homage to Houbigant's floral perfumes, Mucha embellished the bust with lilies over the ears. The bust was set in the middle of the display, above a wreath of irises, roses and violets, where the combination of youthful beauty, distant and serene, and the crown of jewels and flowers provided the perfect symbol for the perfume maker's arts.

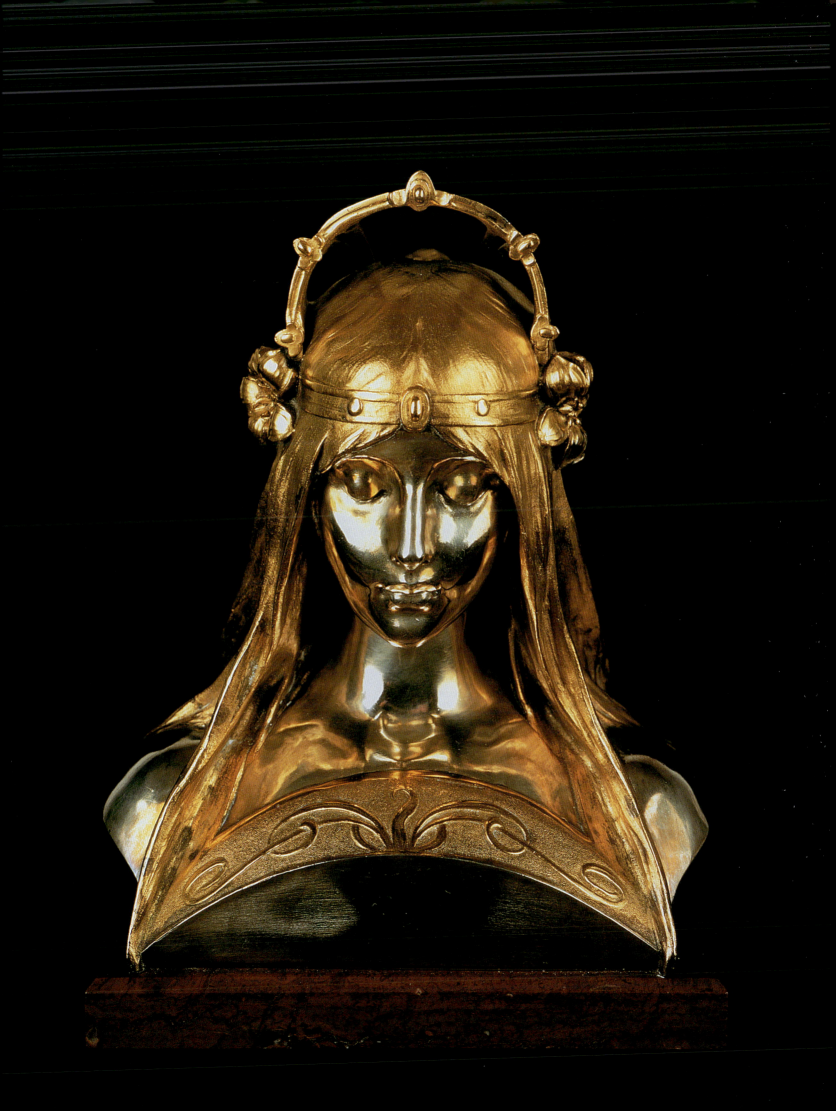

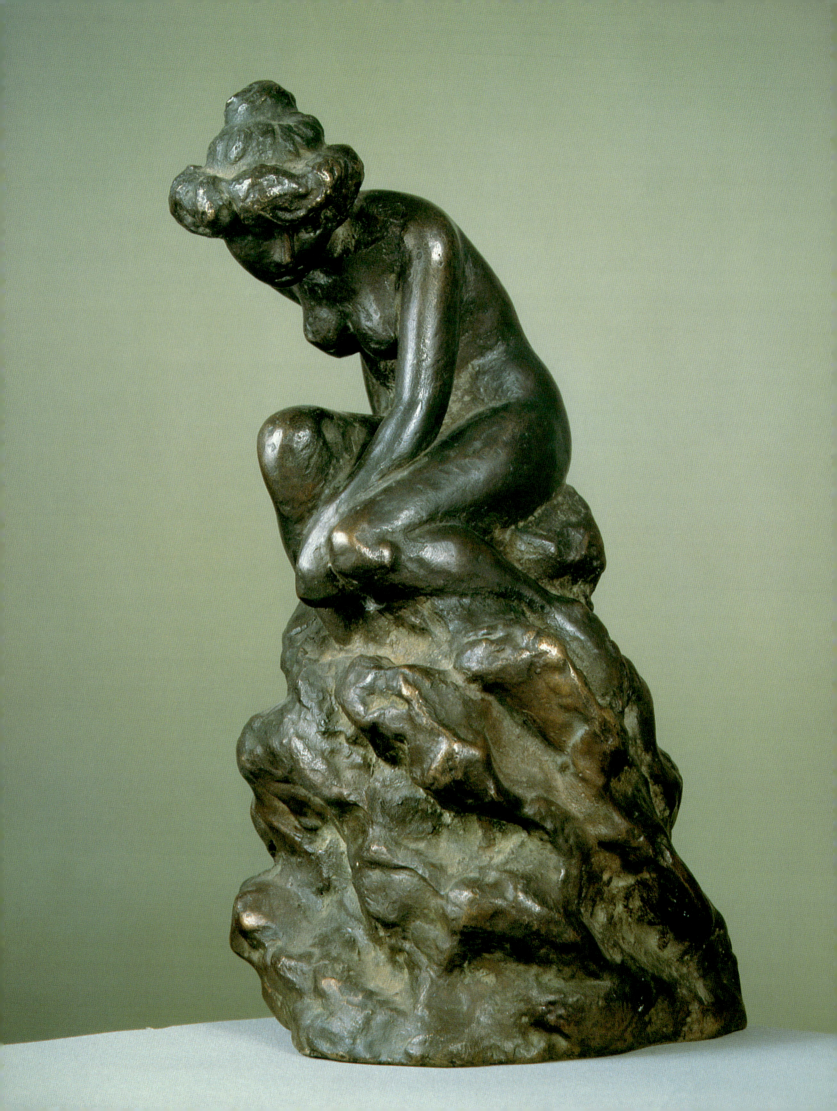

Nude on a rock
1899
bronze
height: 27 cms

Mucha first started working in sculpture a year or two before the International Exhibition in 1900 and many of his sculptures are directly linked to this event. He was encouraged to experiment by two of his closest friends, both sculptors. Auguste Seysses' studio was on the ground floor below Mucha's in the rue du Val-de-Grâce. Seysses let Mucha use his work-space and collaborated with him on his sculptures. Mucha was also a close friend of Auguste Rodin whose influence may be seen in this free and lifelike treatment of a young woman who, like Narcissus, gazes down to admire her reflection in the water below the rock on which she is seated.

The realistic treatment of this sculpture sets it apart from all other recorded pieces of sculpture attributed to Mucha which are more formal and idealised in style. It was probably made while he was working on his designs for the *Pavilion of Mankind*, which incorporated monumental realistic sculptures.

MUCHA and FOUQUET

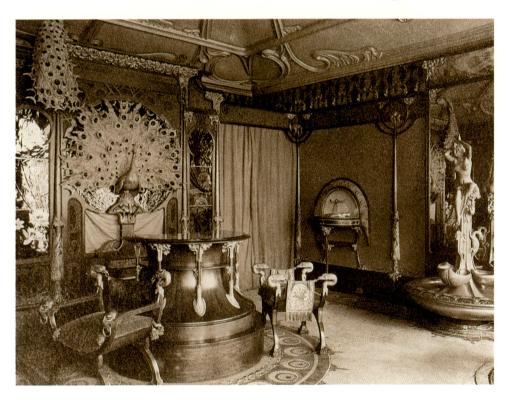

Mucha's collaboration with the jeweller Georges Fouquet resulted in some of the most extraordinary and extravagant examples of Art Nouveau. Georges Fouquet was the son of Alphonse Fouquet, one of the most successful jewellers in Paris in the late 19th century. When Georges took over the family business in 1895 he was determined to make a mark for himself independent of his father's reputation and to discover new forms of expression in jewellery. He intended to launch his new style at the Paris International Exhibition in 1900 and he asked Mucha to help him. It is likely that he was led to approach Mucha because his eye had been caught by Mucha's use of sumptuous and startling jewellery in his posters.

Despite the disconcertingly strange and extraordinary nature of the jewellery designed by Mucha, Fouquet's stand at the Exhibition was a great success and was widely noticed by and commented on by the critics. Only a handful of the major pieces of jewellery produced as a result of Mucha and Fouquet's collaboration survive, the rest are known only through photographs. These give evidence of a creativity and exoticism that go far beyond the standards of an era well known for its taste for novelty. Through his work with Mucha, Fouquet's desire to revitalise the aesthetics of jewellery through a new approach to design was amply achieved.

It is not surprising, therefore, that when Fouquet decided to move his shop, he again called on Mucha. The new boutique was to be in the rue Royale, further from the traditional jewellery quarter of Paris but in an area where trade in luxury goods was on the increase. Mucha used the opportunity to create a manifesto of the new aesthetic, a building which was itself a complete work of art. He designed all aspects of the boutique – both exterior and interior. His intention does not seem to have been to create a functional and efficient commercial space, instead he focused on creating an atmosphere, a jewel of a space which would create a magical ambiance and act as a perfect backdrop to the spirit of the new jewellery. Mucha drew inspiration for the decoration of the boutique from the natural world, branches, flowers, butterflies, gems, corals and fish. Pride of place is given to two spectacular sculpted peacocks set against glowing designs in stained glass.

The shop opened in 1901 and was greeted with enthusiasm. An article by A. Robert in the *Revue de la Bijouterie* welcomed it thus: 'Yes, the creations of Art Nouveau require a new kind of framework, a framework which will set the artwork off effectively and which will thus create a harmony. Everyone thinks so, everyone says so.. Everyone hesitates, everyone waits.. And now, suddenly, someone has been brave enough to make it a reality. He has opened a new kind of shop in the very heart of Paris. He has raised it to the level of his art, furnished it in accordance with the canon of his soul and he has done it so brilliantly that the jeweller and his products find themselves in a milieu which is so appropriate to its intended application that it almost seems to be a talking sign.'

Fouquet retained Mucha's design until 1923 when changing tastes demanded a more up-to-date shop. However, Fouquet was too fond of Mucha's revolutionary design to allow it to be destroyed. Instead he dismantled the boutique piece by piece and arranged for it to be stored in a furniture warehouse. In 1941 he gave it to the Musée Carnavalet for safekeeping where it remained in storage until the 1980s. The painstaking job of reconstructing the boutique was finally and triumphantly completed in 1989. One of the most spectacular examples of Art Nouveau decorative design may now again be enjoyed in all its glory.

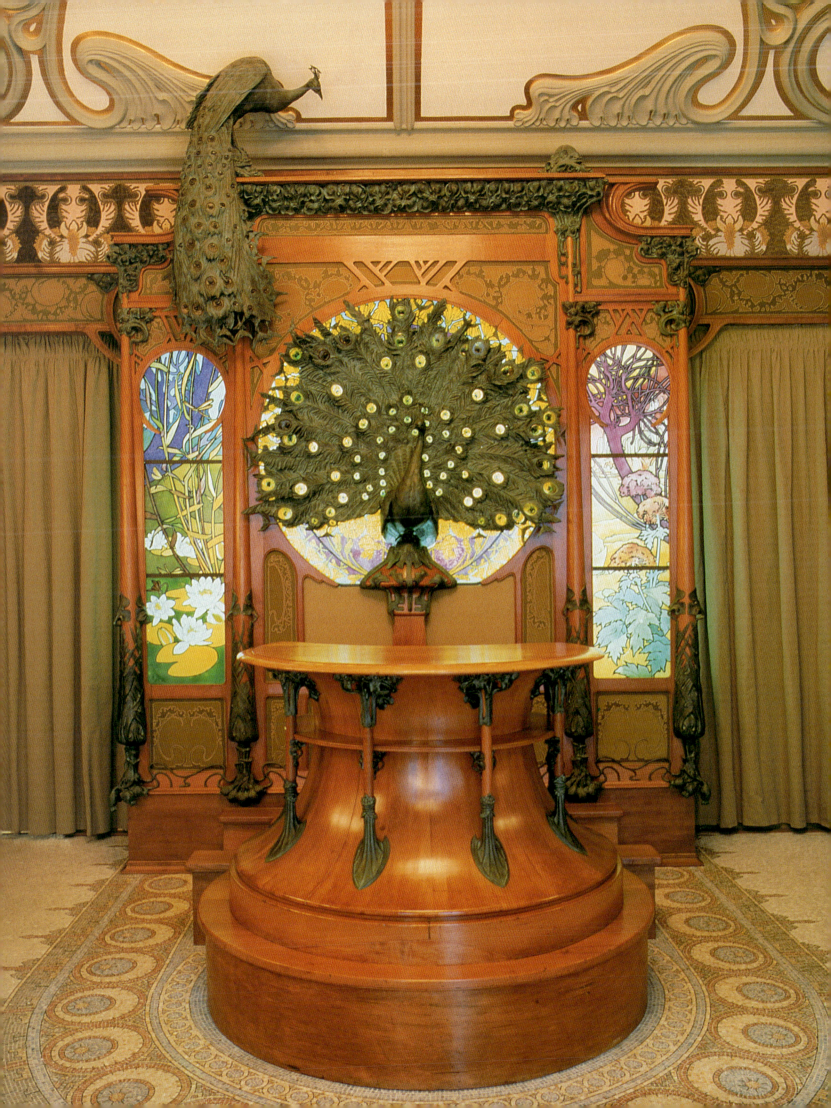

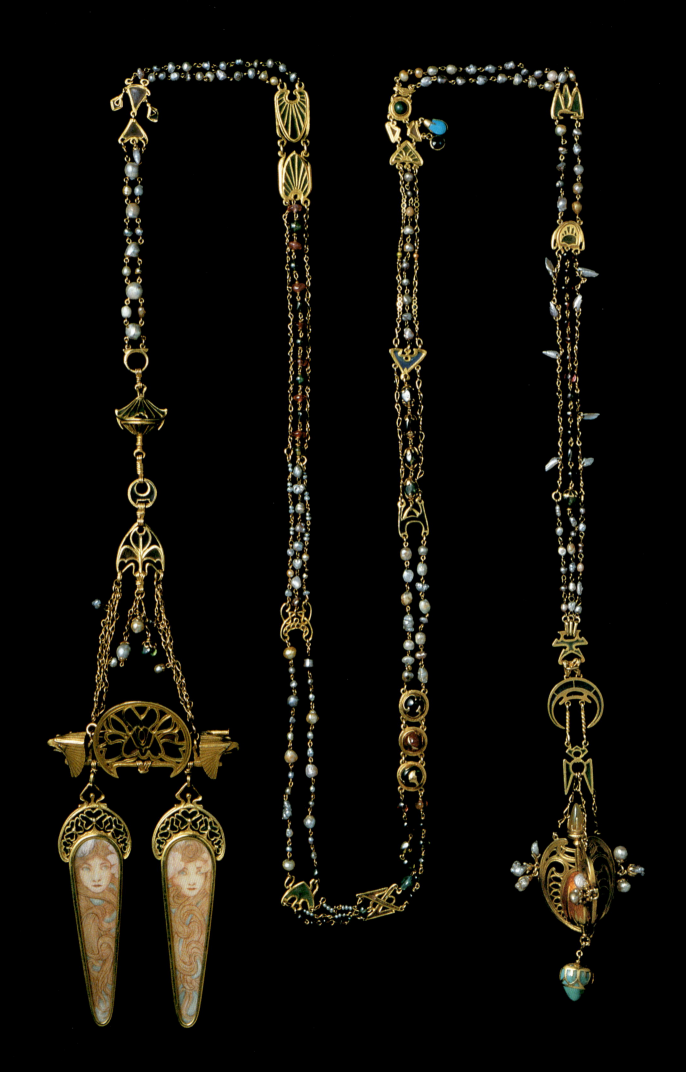

France Embraces Bohemia
c 1918
oil on canvas
122 x 105

In this highly symbolic painting, the sufferings of the Czech nation under Austro-Hungarian rule are represented by the naked woman wearing drapery on which the Lion of Prague is depicted. She has been tied to a cross which stands in a fiery wasteland. The revolutionary spirit of France, wearing the Phrygian bonnet, comforts her with a kiss, at the same time liberating her from her bonds.

As the Czech nation struggled for its independence, it drew inspiration from the post-revolutionary French nation. After Czechoslovakia had won her independence in 1918, the new President, Tomáš Masaryk wrote: 'A fellow feeling for France, and for the ideals of the French Revolution, was a powerful intellectual and political support for us at the time of our national revival.'

Girl with Loose Hair and Tulips
1920
oil on canvas
76.8 x 66.9

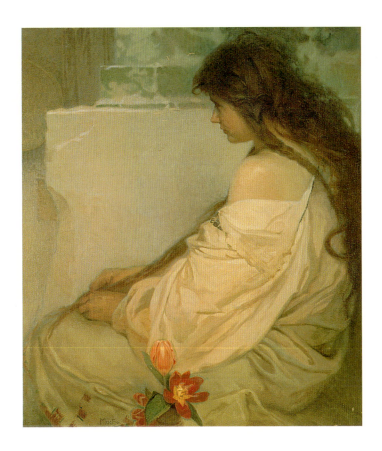

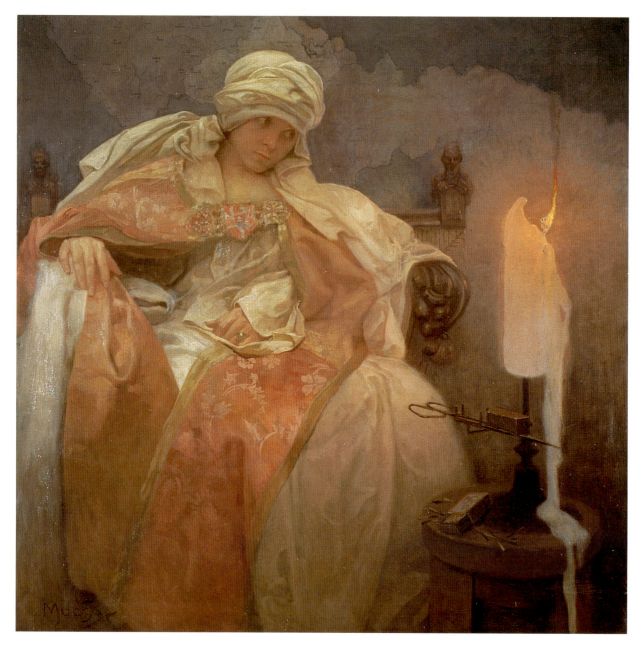

Woman with a Burning Candle
1933
oil on canvas
78 x 79

<div style="text-align:right">

Madonna of the Lilies
1905
tempera on canvas
247 x 182

</div>

Dressed in sumptuous robes and wearing the national coat of arms of the Czechoslovak Republic on her decorative clasp, a woman sits in a throne-like wooden chair and stares intently at a candle. Both the impressive cascade of melting wax which has run down over the stand and the nearby collection of spent matches indicate that her vigil has been lengthy.

Candles have long been used to measure time and, since Mucha painted this picture in 1933, the 15th anniversary of Czechoslovak independence, the woman may be seen as the guardian of her country's flame. Candles are also a symbol of the brevity and fragility of life, thus the woman may be contemplating the uncertain future of her country against the backdrop of the rise of fascism in neighbouring Germany.

In 1902 Mucha was asked to decorate a church in Jerusalem dedicated to the Virgin Mary. The project was later cancelled but not before Mucha had created this painting. Mucha called the subject *Virgo purissima* and surrounded the heavenly vision of the Madonna with a mass of lilies, symbol of purity. The seated young girl in traditional costume carries a wreath of ivy leaves, symbol of remembrance. Her serious expression and strong physical presence contrast with the ethereal figure of the Virgin. Another picture of the model for the young girl is included in *Figures décoratives* Plate 8.

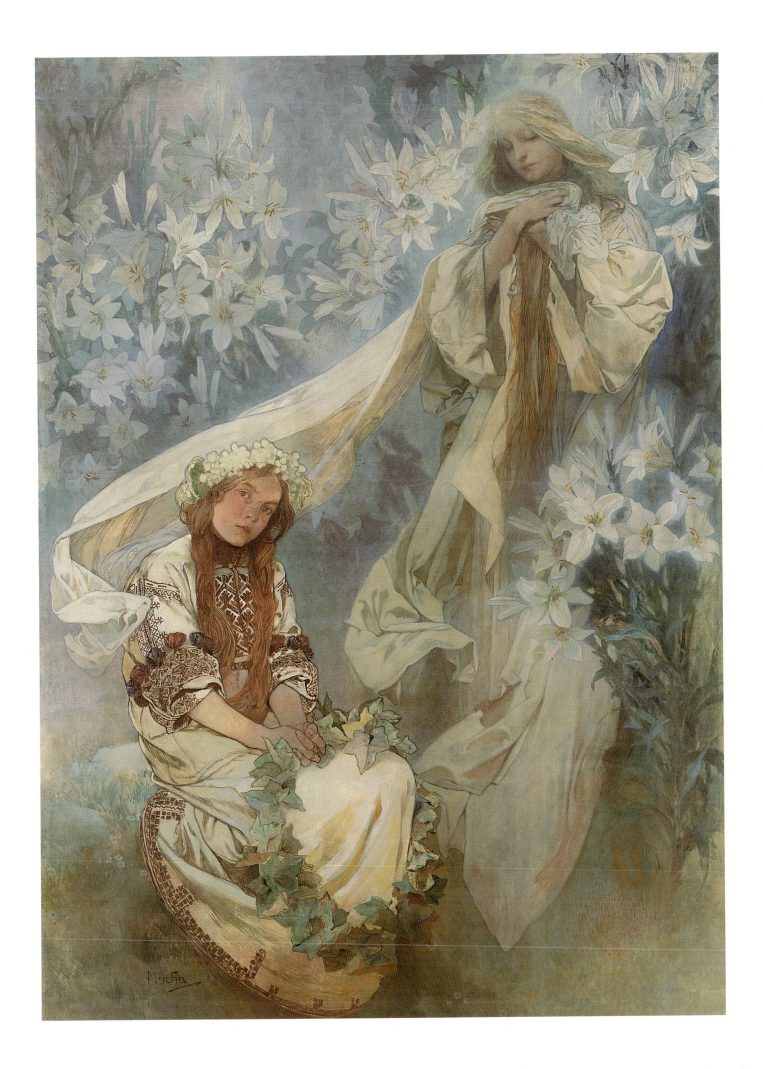

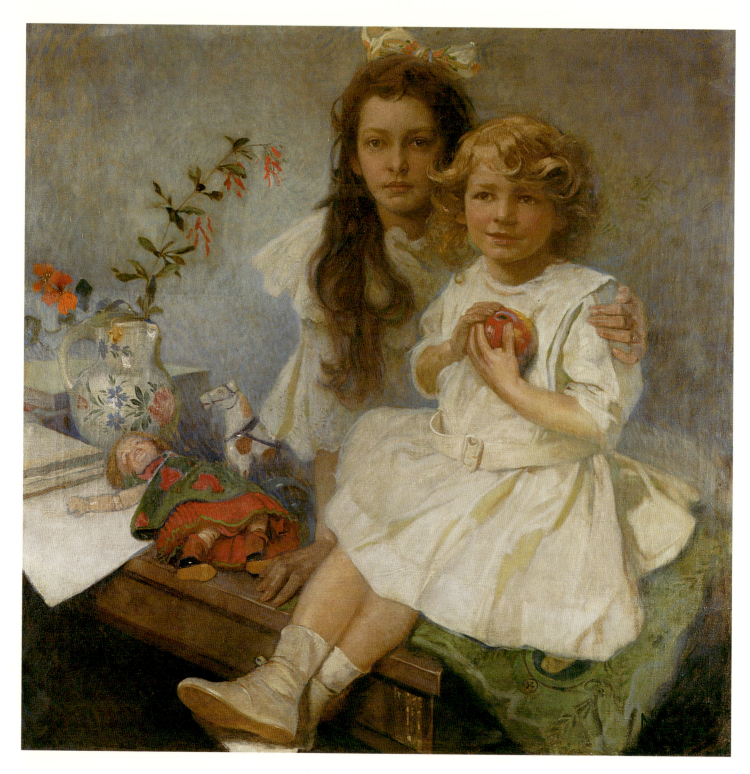

Jaroslava and Jiří – The Artist's Children
1919
oil on canvas
82.8 x 82.8

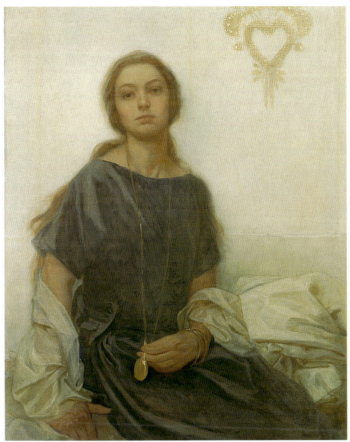

Portrait of Jaroslava
c 1930
oil on canvas
82 x 65

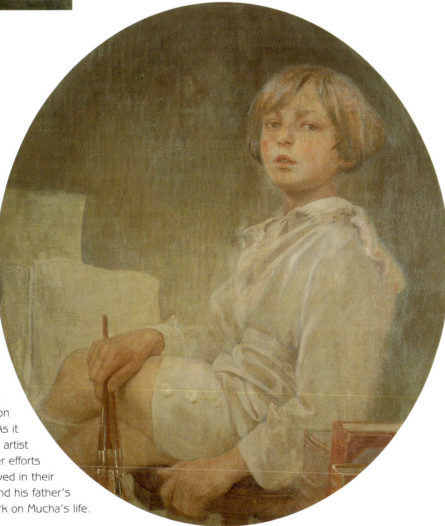

Portrait of Jiří
1925
oil on canvas
72 x 65 oval

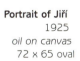

Mucha painted many portraits of his children as
well as using them as models in many other works.
As the painting of Jiří shows, Mucha wanted his son
to follow in his footsteps and become an artist. As it
happened, it was his daughter who became first an artist
and then a picture restorer. It is largely due to her efforts
that the canvases of the *Slav Epic* have survived in their
present condition. Jiří became instead a writer and his father's
biographer, producing the definitive work on Mucha's life.

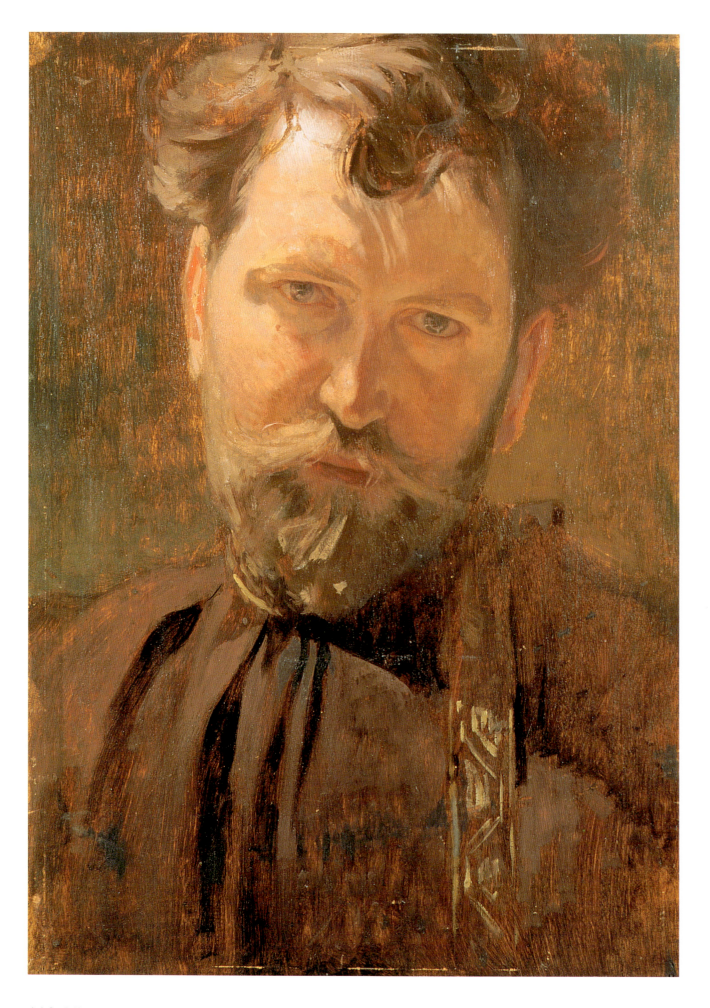

Self-portrait
1899
oil on board
32 × 21

Portrait of Maruška
1903
gouache on board
50.7 × 32.1

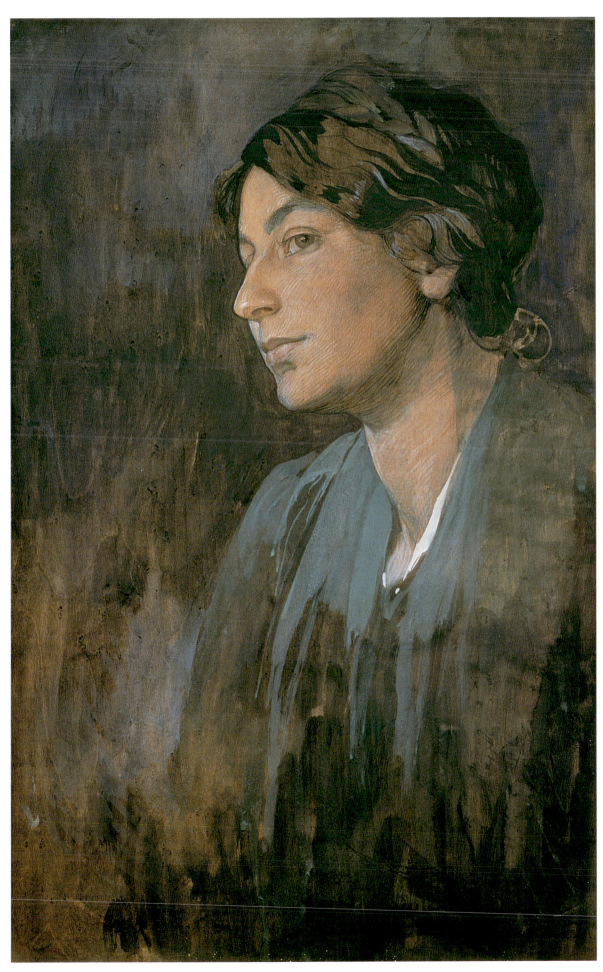

PHOTOGRAPHS

Mucha's photographs fall
into three broad areas: photographs of models for use in paintings,
photographs taken on study trips abroad – notably to the Balkans in
1912 and Russia in 1913 – and photographs of family and friends. The
Mucha Foundation's collection of photographic material is a mixture of
vintage prints, developed and printed by Mucha himself, and in many
cases marked up for transfer to a painting, and of negatives –
both glass and celluloid.

Mucha first began to take photographs in Munich with a borrowed
camera. It was not until he had gained some recognition in Paris and
sufficient funds that he purchased one himself. By 1896, when he
moved to a large studio in rue du Val-de-Grâce, he had two cameras –
one 12 x 9 cms and one 18 x 13. The glass plates he kept in wooden
crates which he took with him whenever he moved. He took his
pictures without any added or artificial lighting, relying on the dispersed
light of the artist's studio. He always developed them himself in an
improvised darkroom and made all the prints by daylight. He did not
enlarge his photographs; contact copies served
his purposes adequately.

In the Paris studio, where he photographed on a virtually daily basis, he
did not as a rule take pictures of models for a specific project. Instead
he preferred to improvise a number of poses in front of the camera,
creating an archive of variants from which he could select what he
considered most suitable for his subject for each new commission.
Later, when he returned to Bohemia, his photographic
compositions were more obviously directed, with
poses created for specific purposes.

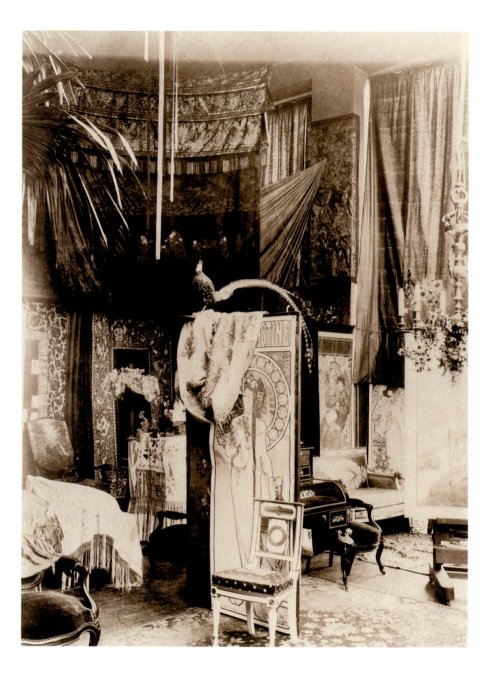

PHOTOGRAPHS
IN THE STUDIO
by Petr Wittlich

IN THE SECOND HALF of the 1890s, Mucha made a remarkable series of photographs of female models, who posed for him in his studio in rue du Val-de-Grâce in Paris. Use of photography as an inexpensive medium for preliminary studies was common among Mucha's Parisian contemporaries. Mucha's photographs are more, however, than just an alternative to sketches because they also capture the inimitable atmosphere of Mucha's studio, a world of art in its own right. It was in his studio that Mucha entertained countless Parisian artists, writers and musicians. It was also the setting for the world's first cinematic projection, given by the brothers Lumière. In the background of the studies of models, who strike poses typical of those in Mucha's Art Nouveau posters, examples of the artist's work may be seen, surrounded by various bizarre objects – stuffed animals, oriental articles and textiles, ecclesiastical sculptures, books and furniture – many of which survive to this day.

Model posing in Mucha's studio
Rue du Val-de-Grâce, Paris c 1898

Model posing in Mucha's studio
Rue du Val-de-Grâce, Paris c 1898

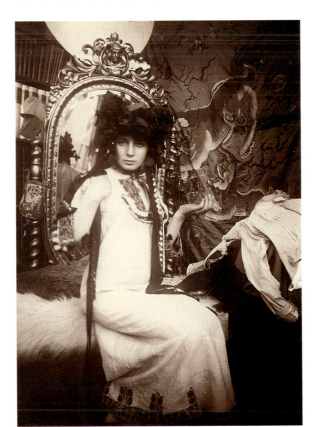

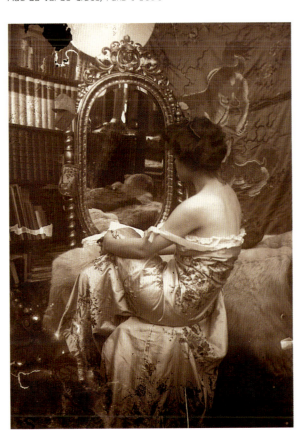

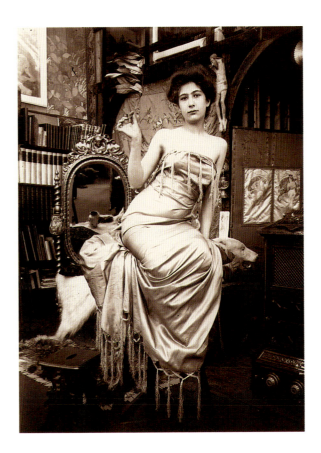

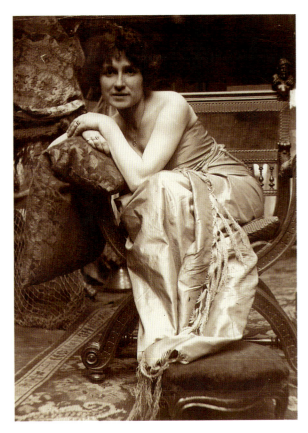

Model posing in Mucha's studio
Rue du Val-de-Grâce, Paris c 1899

Model posing in Mucha's studio
Rue du Val-de-Grâce, Paris c 1900

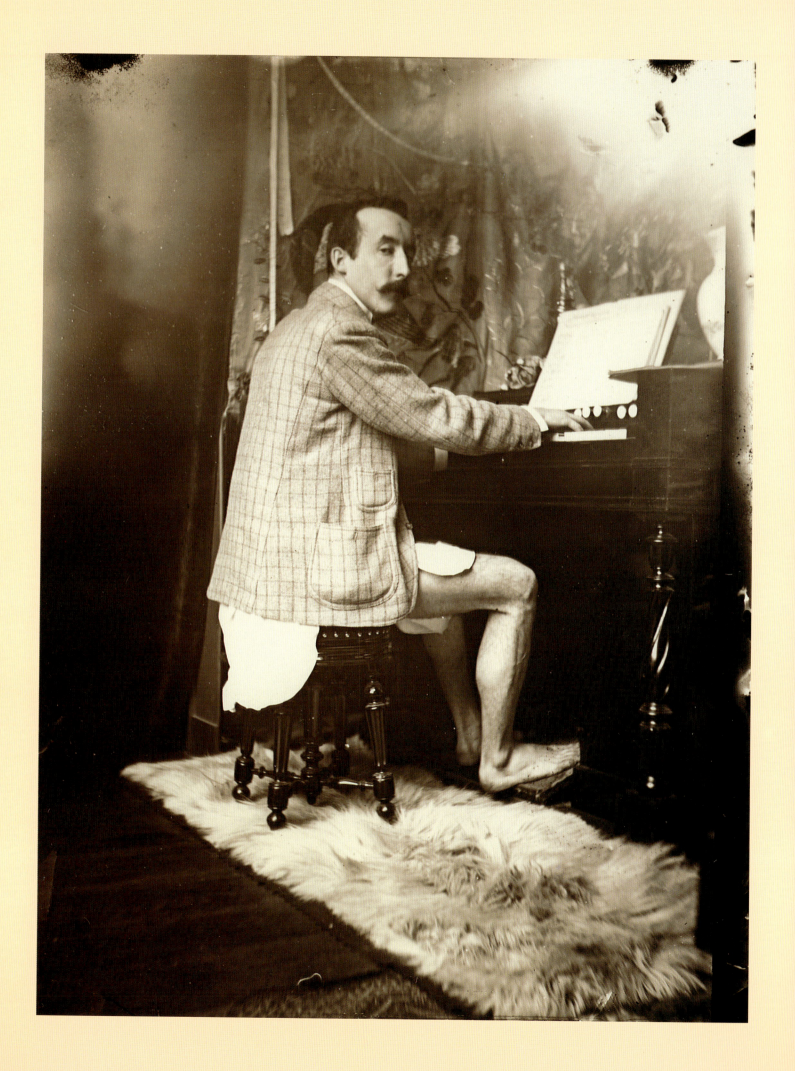

Paul Gauguin playing the harmonium in Mucha's studio
Gauguin shared Mucha's studio when he was preparing for his first Paris exhibition.
Rue de la Grande Chaumière, Paris c 1895

Study for *Comedy* for the German Theatre in New York
New York 1908

Model posing in Mucha's studio
Rue du Val-de-Grâce, Paris c 1902

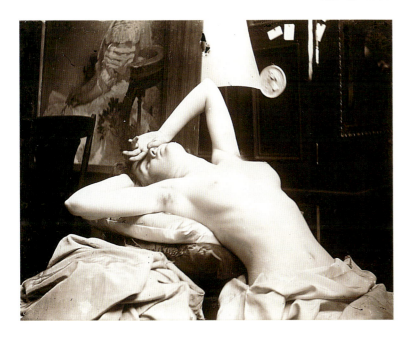

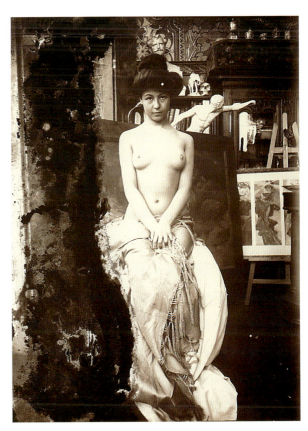

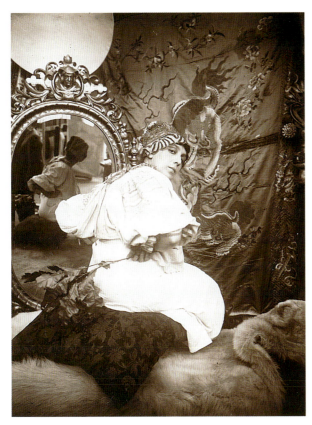

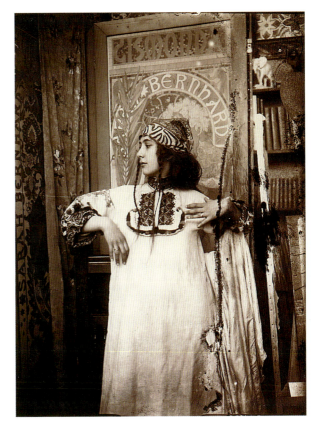

Model posing in Mucha's studio
Rue du Val-de-Grâce, Paris c 1900

Model posing in Mucha's studio
Rue du Val-de-Grâce, Paris c 1898

Model posing in Mucha's studio
Rue du Val-de-Grâce, Paris c 1900

Model holding a wreath
Rue du Val-de-Grâce, Paris c 1900

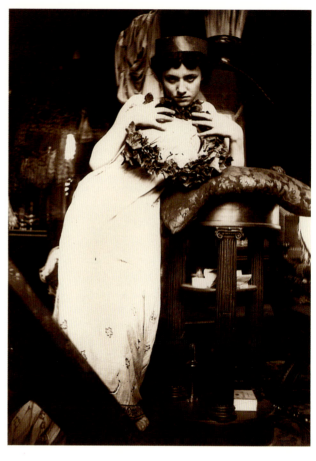

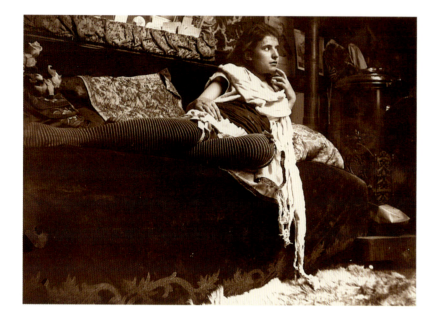

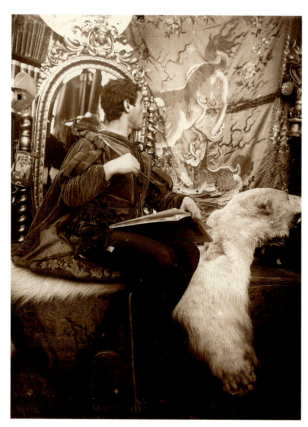

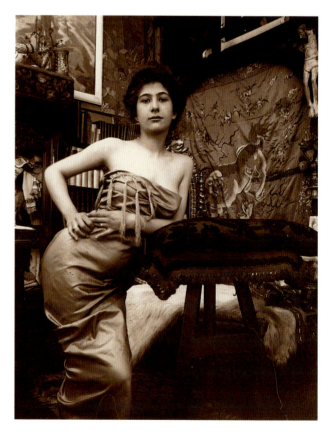

Model posing in Mucha's studio
Rue du Val-de-Grâce, Paris c 1898

Model posing in Mucha's studio.
Rue du Val-de-Grâce, Paris c 1899

THE LEGACY OF MUCHA'S PHOTOGRAPHS

by Jan Mlčoch

Curator of Photography
Museum of Decorative Arts, Prague

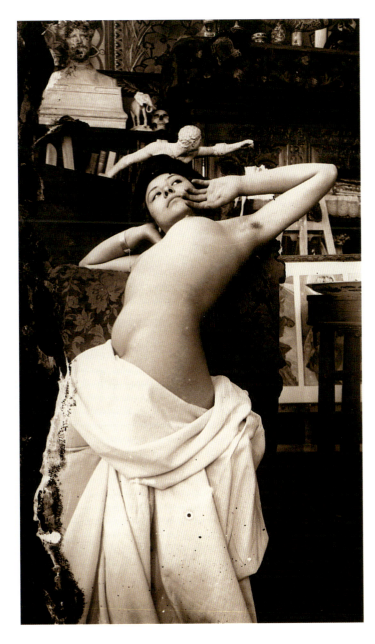

Model posing in Mucha's studio
Rue du Val-de-Grâce, Paris c 1902

Painting and photography were closely interlinked during the 19th century. Initially photography sought inspiration in the age-old painting tradition but it soon became emancipated to the degree that it began itself to influence painting and other artistic fields. As a working method for the purpose of capturing studies of figures, drapery and arranged scenes and landscapes, artists also used photography to create more complex compositions.

Mucha began to take photographs while studying in Munich and developed a number of photographic genres over the years. These include documentary shots of street life (Munich during the 1880s, occasionally Paris, Moscow in 1913) personal documentation (portraits and self-portraits, friends in his Paris studio and, later, family photographs) landscape studies and studies of models, either individually or within complex arrangements of scenes for the different canvases of the *Slav Epic*.

Mucha's photographs should not be seen merely as an accessory to his more familiar graphic art. While they fulfil the decorative requirements of Art Nouveau they reveal traits which render them unique and independent works of art. An explanation may be found in the photographic technique itself, which presents the subjects faithfully – communicating not only their grace but also their physical imperfections. The subsequent transfer of the compositions to a 'more artistic' final medium washed away some of the rawness and immediacy possessed by the photographs which are today regarded as a true virtue. The photographs are dazzling for their ability to show us what lies beyond the mirror – the key figures of the *Belle Époque* are smiling young women whose features and complexions are frequently coarse.

For Mucha his photographs were not art; they were produced without embellishment and were treated for what they were. Just as in the graphic field, there is a tension between the sweet elegance of many of Mucha's works and the more expressive and darker undercurrent which finds expression in the pastels, so there is an echoing tension in the photographs. It should be remembered that at this time other photographers created and altered their photographic prints with the aid of various techniques which were meant to suppress the undesirable naturalism of the original negatives. This was not Mucha's aim and his surviving legacy provides a unique example of modern photography at the turn of the 20th century.

THE ARTIST'S FAMILY

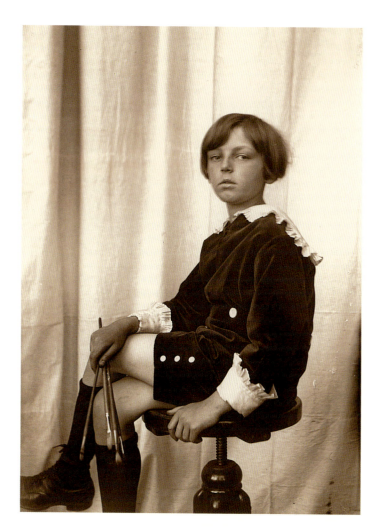

Portrait of Jiří
1925

Portrait of Jaroslava
c 1930

Self-portrait
Alphonse Mucha
wearing a
Russian shirt
Paris c 1898

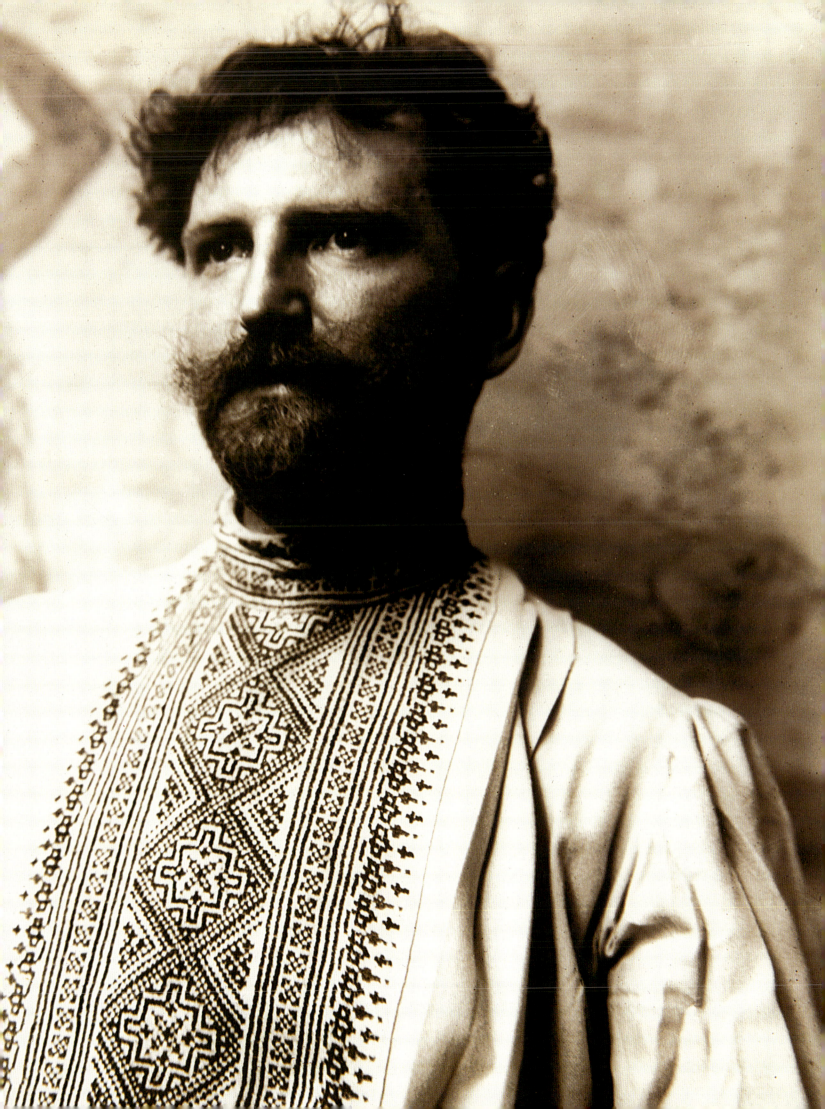

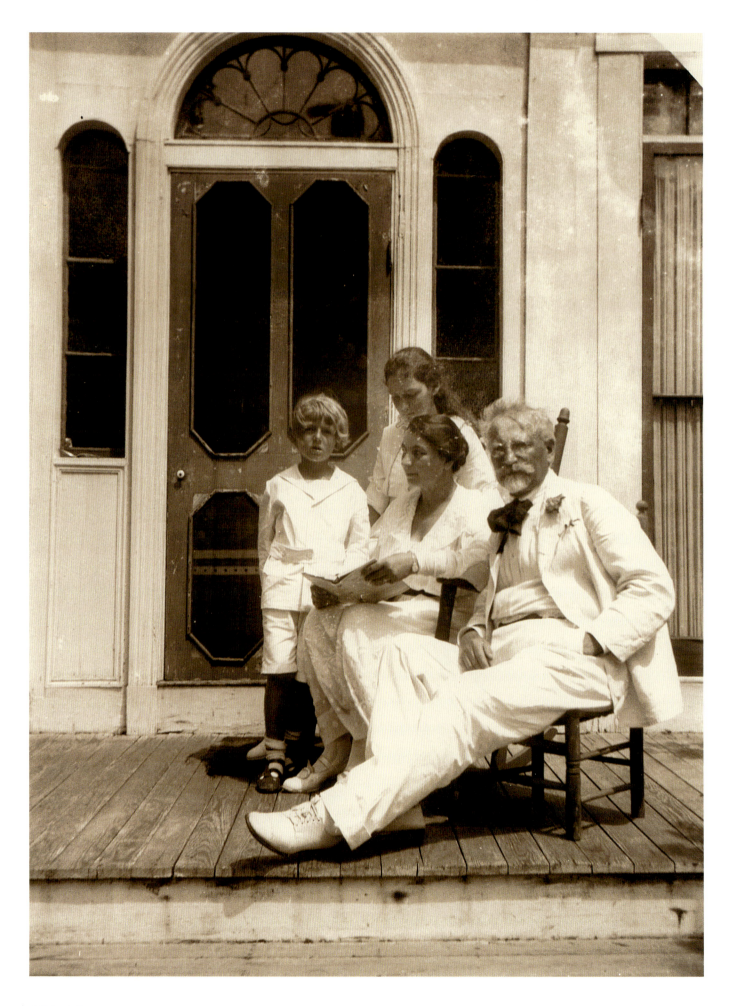

**Family together
at Cape Cod**
1921

Maruška with Jiří
1915

Maruška with Jaroslava and Jiří
Bohemia 1923

Maruška with Jaroslava and Jiří
Bohemia c 1923

Maruška with Jaroslava
Bohemia c 1930

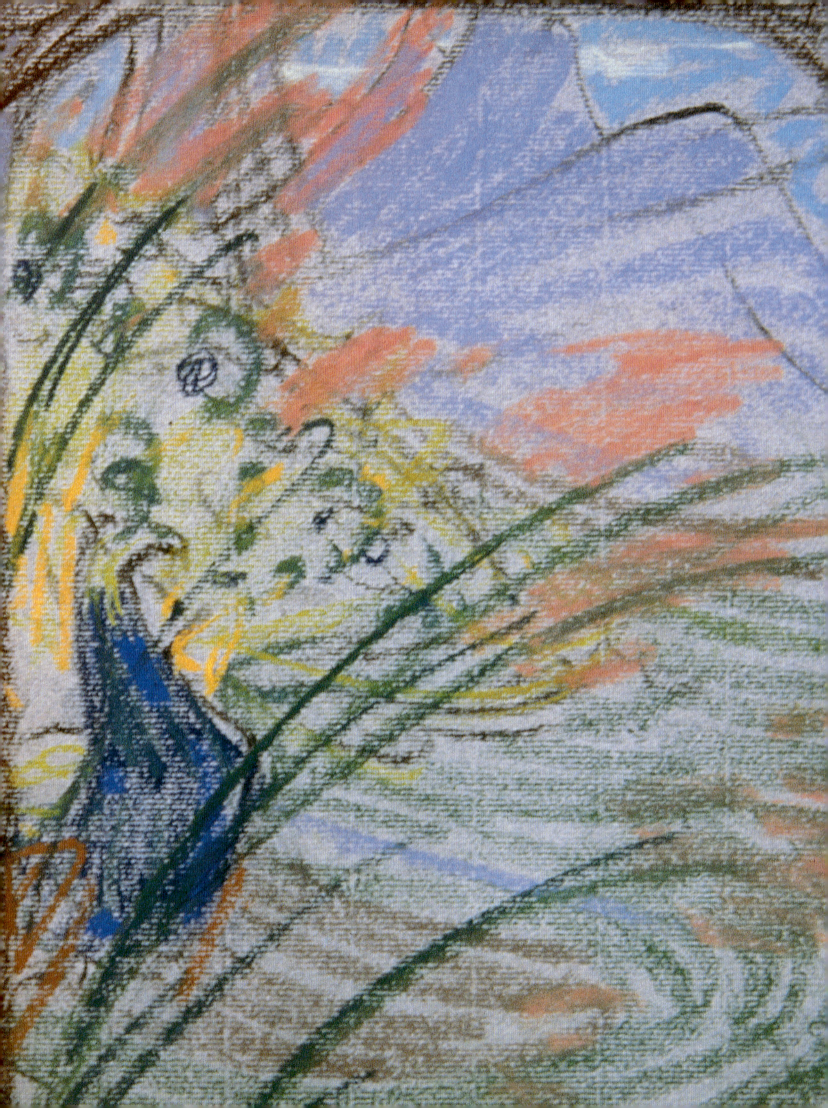

DRAWINGS AND PASTELS

by Petr Wittlich

Mucha's free drawings and pastels demonstrate a remarkable breadth of creativity. His meticulous pencil studies contrast with the unusually expressive design projects in other media, such as *Design for Ceramics and Glass* c 1900, and *Design for a Window* c 1900. These works in particular bear witness to an inner unity in the content of Mucha's work based on his philosophical ideals. They form a direct link to the remarkable set of expressive pastels by Mucha, whose date of origin and inspiration still remain a mystery to a large extent.

Crucifixion
c 1868
watercolour on paper
37 x 23.5

One of Mucha's earliest known compositions, *Crucifixion*, made when he was about 8 years old, shows the clear influence of the Catholic Church both in subject matter and style.

From his earliest days, the Catholic Church exercised an influence over Mucha's sensibilities. It formed an important part of his childhood even before the age of ten when he became a chorister at St Peter's Church in Brno. Later he wrote of his childhood impressions in church at Easter: 'I used to kneel for hours as an acolyte in front of Christ's grave. It was in a dark

alcove covered with flowers heavy with intoxicating fragrance and wax candles were burning quietly all round with a sort of sacred light which illuminated from below the martyred body of Christ, life-size, hanging from the wall in utmost sadness... How I loved to kneel there with my hands clasped in prayer. No-one in front of me, only the wooden Christ hanging from the wall, no-one who could see me shutting my eyes and thinking of God-knows-what and imagining that I am kneeling on the edge of a mysterious unknown future.'

Kolonohorukorychlotoč
1887
pen on paper
49.5 x 32.2

Ivančice Diploma
1882
watercolour and pen on paper
37 x 24

Although Mucha had to leave Ivančice in order to pursue his intended career as an artist, he kept in close touch with his family and friends back home. He made many illustrations for the local satirical magazines, *Slon* and *Krokodýl*, which were published by his brother-in-law Filip Kubr. The mock diploma, which purports to be honouring a local celebrity, is notable mainly for its sensitive illustration of the first line of *Máj*, `It was the first of May, it was the time of love', by Karel Hynek Mácha, one of the most admired Czech poets.

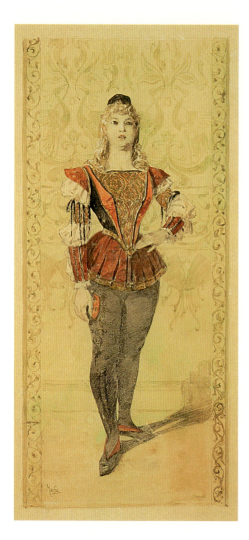

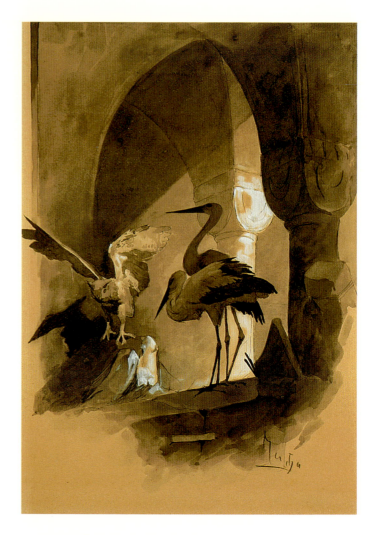

Page's Costume
Study for an illustration for *Le Costume au Théâtre*
1890
pencil and watercolour on cardboard
35.3 x 25

At the Sight of the Two Storks, the Owl Rose
Study for an illustration for *Contes des grand'-mères*
1891
watercolour and white on paper
33 x 24

The publisher Lemercier gave Mucha a quasi permanent job
making illustrations for *Le Costume au Théâtre*, a magazine
devoted to the reproductions of stage sets and costumes from
new productions in opera and theatre. His work with the magazine
provided him with a fee and free tickets to plays. It was while he
was working for *Le Costume au Théâtre* in 1890 that Mucha first
drew Sarah Bernhardt as Cleopatra in the play by Émile Moreau.

Mucha provided forty-five text illustrations and ten full page
compositions for the book of fairy tales *Contes des grand'-mères*
by Xavier Marmier, published in 1892 in Paris by Librairie Furne,
Jouvet et Cie. The publisher Jouvet was so impressed by the
illustrations that he decided to submit them for exhibition at the
Salon where, to Mucha's surprise and delight, they received an
honourable mention.

Study of a woman sitting in an armchair
c 1900
washed indian ink on paper
60.5 x 43.5

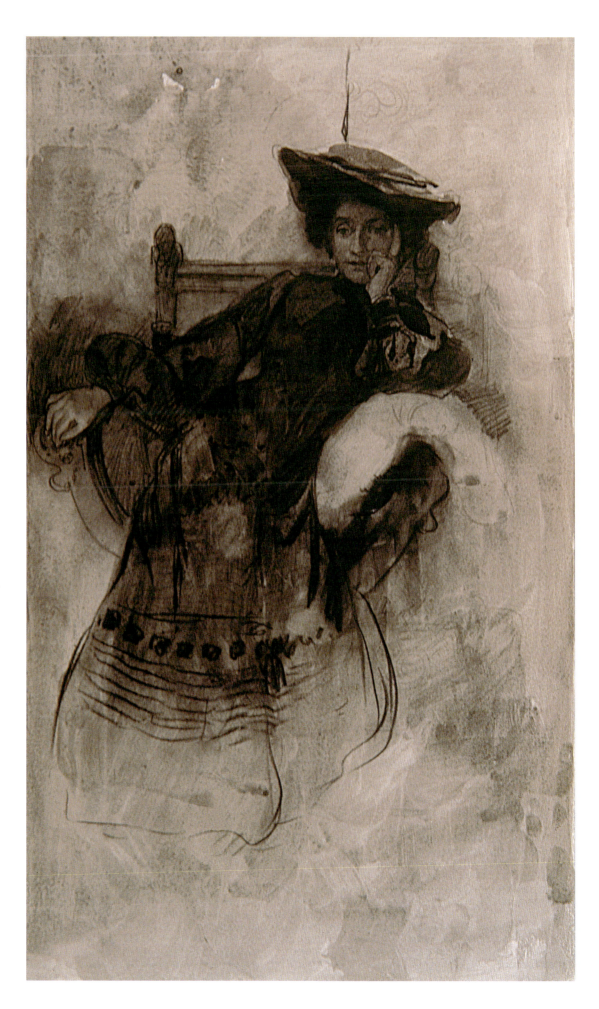

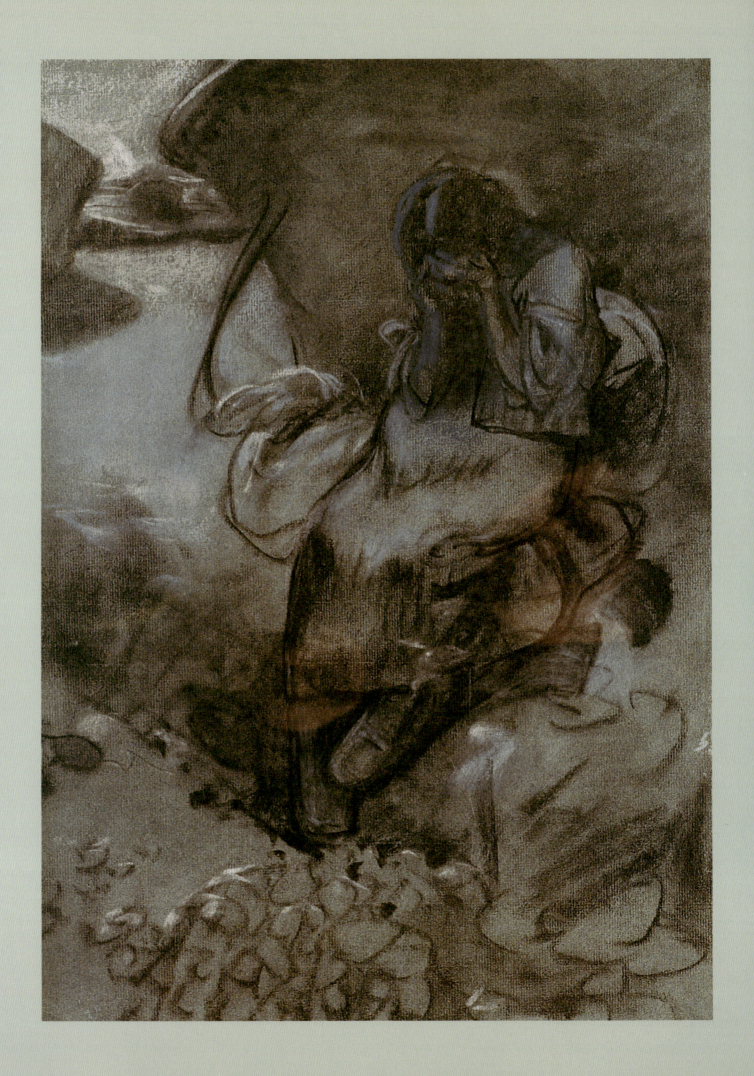

Weeping girl
c 1900
black chalk and pastel on blue paper
47.5 x 32.3

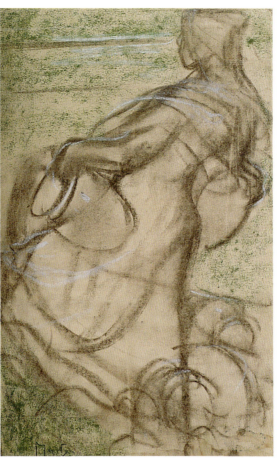

Woman carrying water vessels
c 1900
charcoal and pastel on paper
46 x 29

Study of hands
after 1910
pencil on paper
60 x 43.5

Study of a woman carrying a platter
c 1890
pencil on paper
48 x 36.5

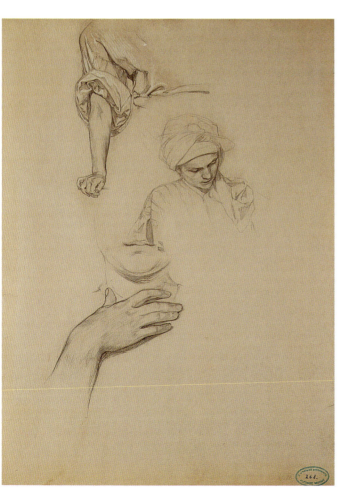

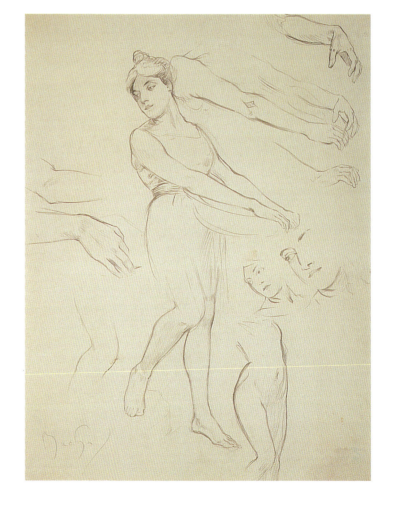

Standing figure
c 1900
charcoal and pastel
on grey paper
62.5 x 47

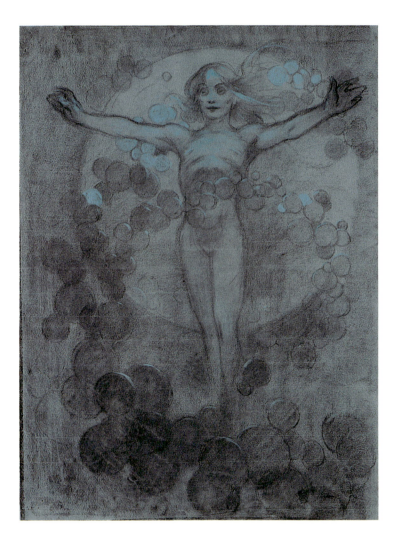

Three studies
c 1900
pastel on grey paper
62 x 47.2

Figural scene
c 1900
charcoal and pastel on paper
35 x 30.5

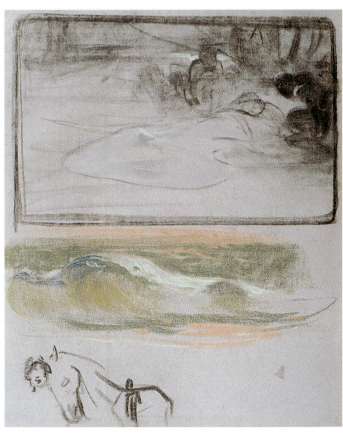

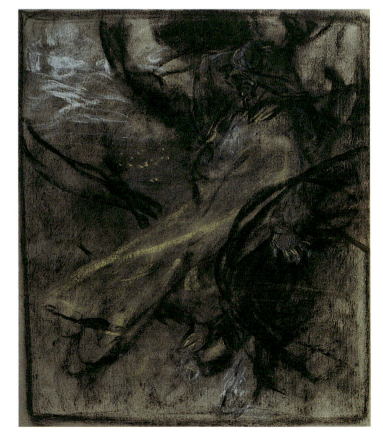

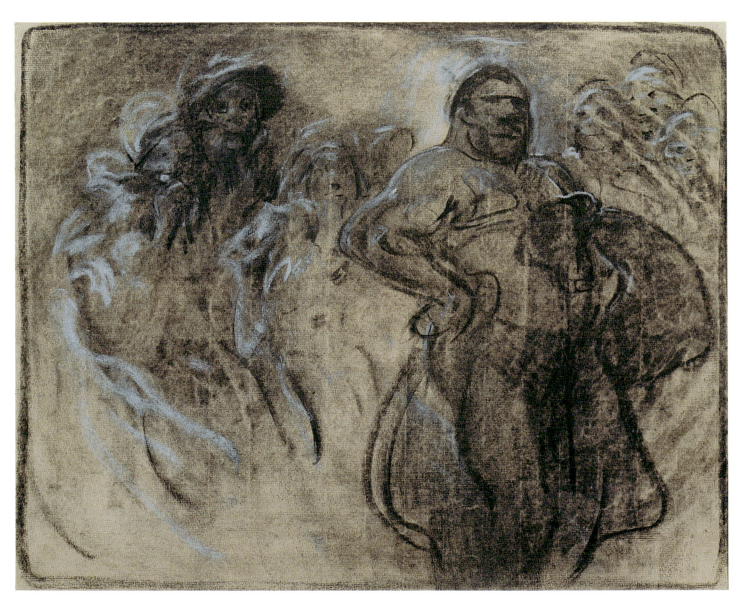

The Wrestler
c 1900
charcoal and pastel on grey paper
47 x 59

Sitting figure – Christ
c 1900
blue pencil on paper
64.6 x 50

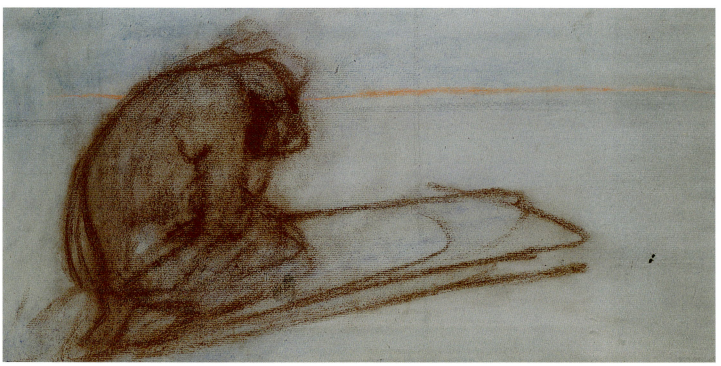

Prayer
c 1896
pastel on grey paper
26 x 52.7

Holy Night
c 1900
pastel on blue paper
60 x 45.5

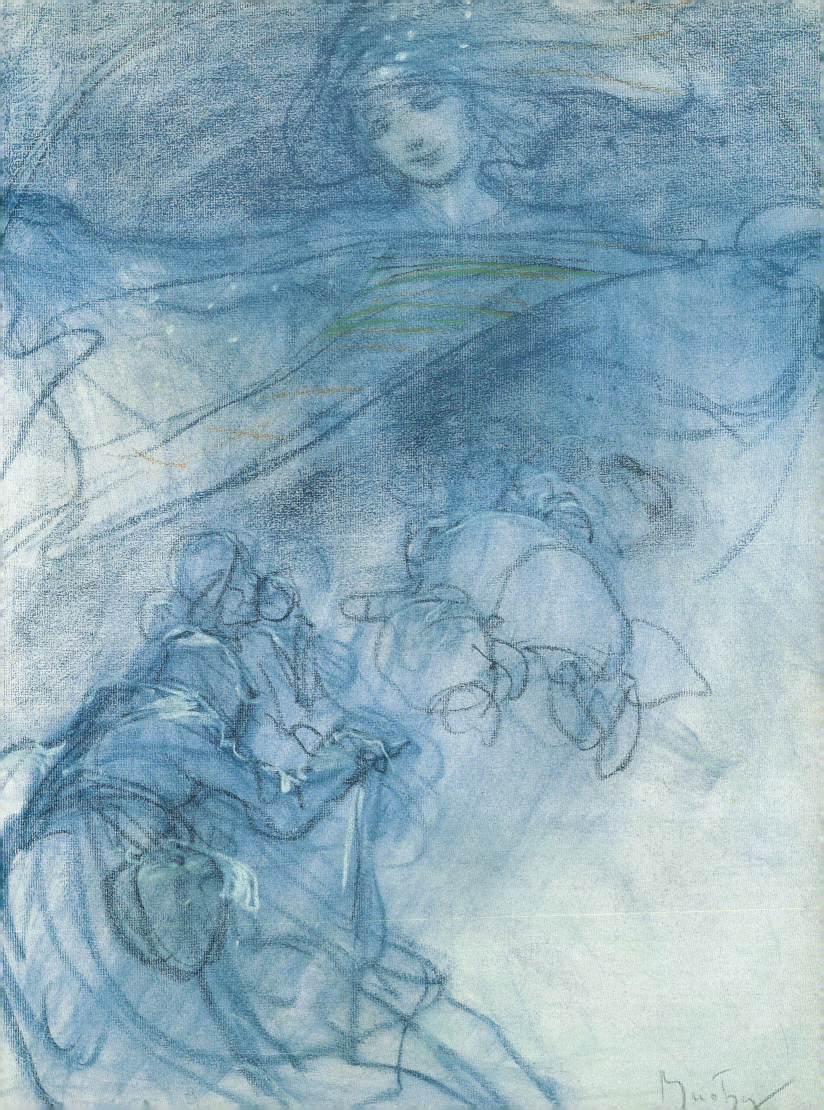